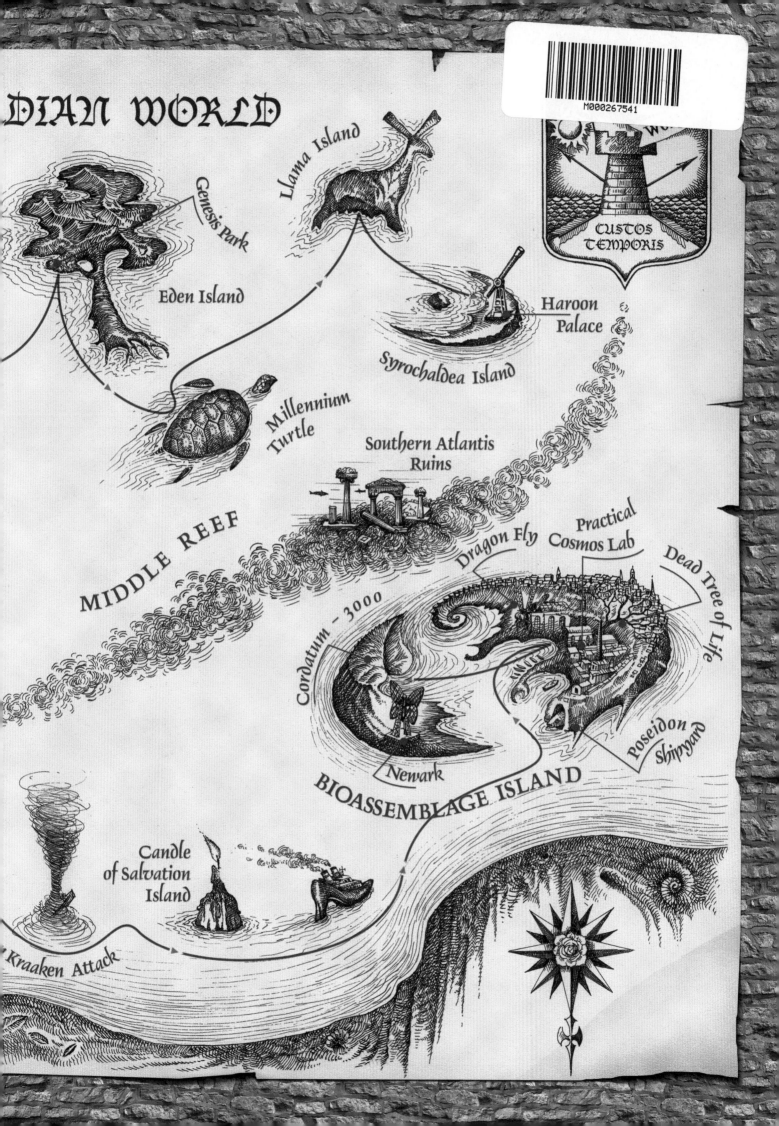

To Helena:

Let the Wings
of Imagination Have you
on the flight of
Human Spirit!!

Journey to the Edge of Time

Kush Fine Art

By Oleg Kush and Mikhail Kush
Based on the works of Vladimir Kush

Journey

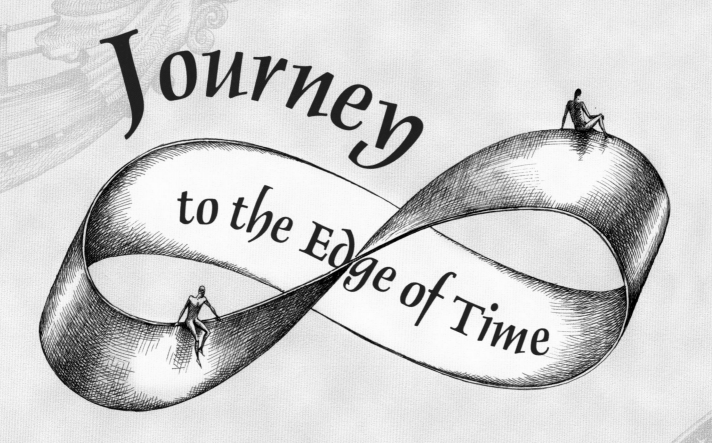

to the Edge of Time

A Diary Recorded by Jason Skysmith,
ChroMec Class of 2339

On the cover:
At the Edge of the Earth. 2003 (Front)
Tree of Life. 2005 (Back)

Kush Fine Art
Lahaina, Hawaii 96761

Designed in Russia by EurasiaXpress Studio
Printed in the People's Republic of China

www.vladimirkush.com

Not all will have the luck to withstand the severe trials that were sent to us by the Sky Powers. For those that do, a safe Sky Haven sheltered in a cloudbank awaits them in a place rich with the golden fruits of new suns and the fair wind of chronons.

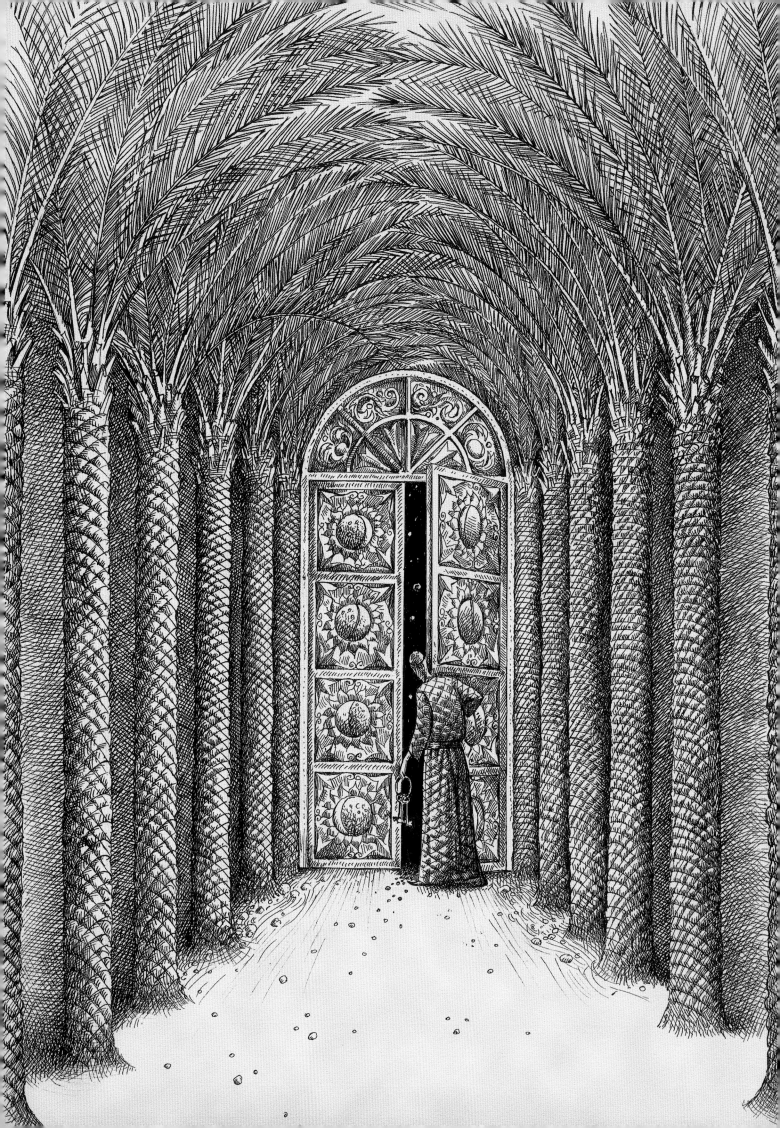

Acknowledgments

The authors, Oleg Kush and Mikhail Kush, dedicate this book to the memory of our beloved son and nephew Alexander Kush, who left us prematurely. His work and ideas were part of our creative world and thus participated in the making of this book. Its creation was a lengthy and involved task.

Our sincere thanks and appreciation go to those who have helped make it become a reality:

Vladimir Kush, our son and nephew, who created the artwork in the book.

Maxim Kompaneets, of EurasiaXpress Studio, who made a great contribution to the design of this book.

Cathy Frye, of The Fresh Eye, in Reston, Virginia, who carefully edited the manuscript and made some valuable additions to the story.

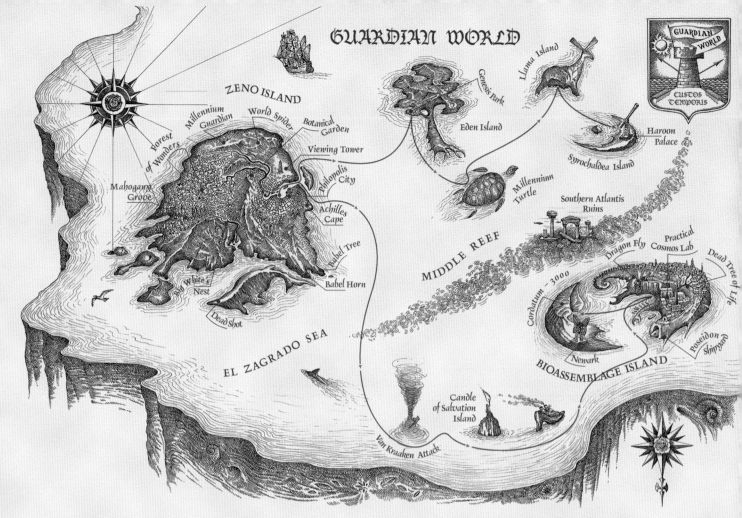

Guardian World Practical

A Diary Recorded by Jason Skysmith, ChroMec Class of 2339

4. Forest of Wonders: The First Trials

5. New Adventures on Zeno Island

6. Trip to Bioassemblage Island

7. Space Mission

Popular

Chronomechanics
&Cosmopraxis

June 2344

Vol.97, Issue 6

6

Inside a ChroM
PRACTI

Special report from the heart of
The GUARDIAl

35
LAST CHANCE:
Win a free Astronomic Safari Invitation

43
Amazil
CREAT

of the GUARDIAN WORLD

Con—

6

2

3

5

A Letter To Our Readers

The editors of Popular Chronomechanics & Cosmopraxis receive many letters, particularly from school-age readers who ask for details of the Guardian World and its amazing creatures. Another common request is for information regarding the everyday work of chronomechanics. Unfortunately, we must resist the temptation to discuss any of these issues here because that could put the work of chronomechanics in danger. As our readers know, the field of chronomechanics is characterized by secrecy because we cannot risk the results of time terrorism. Yet, we realize that the next generation of chronomechanics, many of whom read our publication, must be inspired with real details from the field.

As a solution to this quandary, this month's issue is entirely devoted to presenting selected fragments of the diary of Jason Franklin Skysmith, a recent graduate of the School of Chronomechanics at New New-Haven who did his compulsory post-educational practicals five years ago in the Guardian World during the summer of 2339. By printing this unclassified view of what it's like to pursue an interest in chronomechanics, the editors hope they have retained the security required by our discipline while allowing our readers to see through the eyes of a bright chronomechanic while he was in training.

Skysmith was born in 2324 in Cheshire, Connecticut, a city in the Northeastern United States. Both his father, an architect commissioned to design settlements on the planets of Nearest Space and several important structures in G-World, and his mother, a geologist specializing in off-world minerals, nurtured his early interest in the sciences.

He showed such a strong aptitude for exact science that, at the age of 10, he was accepted by the School of Chronomechanics. At the time of this printing, he holds a doctorate in chronocosmological sciences and is a noted chronomechanic of the third category who participated in the historic first expedition of the spacecraft Newark. When he is not lecturing on time terrorism, he can be found enjoying his hobbies, which include both playing and listening to music in today's quickly-prickly call style, and drawing with pen and ink. Many of the illustrations in this issue were based on his original drawings. He also is an avid fan

Explore G-World through the eyes of one of the field's top, young chronomechanics.

of football and counts the captain of the ChroMec Croni team, which won the 2338 Cup of Three Continents, among his closest friends.

For the best understanding of the realities of these unearthly places, we have annotated Dr. Skysmith's original diary to include excerpts from the encyclopedia, All About MetaCosmion. Interesting information on these issues also can be found on the site: www.megauniverse.luxeterna.

Ronald D'Arcy Dobbson
Editor-in-Chief

Popular Chronomechanics & Cosmopraxis
MetaCosmoPress Edition

On the Cover
The Tower of the World Spider is only one of the wonders revealed in this issue's special report.

Vol. 97, Issue 6 ■ Ju

To Jason — Congratulations on completing five years of difficult studies at ChroMec. Hard to believe your dream of becoming a chronomechanic is so close already. Observe well, brace yourself for the unexpected, and stay safe.

All our love throughout time and space,
Mom & Dad

June 1, 2339

Archive

Guardian World (also, short form: G-World) is a closed zone of the globe in which the scientific organizations that ensure the protection of Space and Time are located. It is situated on a giant plateau called Pillar, in the Southern Ocean. G-World was created as a result of a man-made geological cataclysm. It is invisible and inaccessible to outsiders because it lies hidden in a fold created by space-time curves and is protected against the Forces of Evil by a special energy field. For security reasons, access is only permitted to scientists and approved visitors. Reached through a special spatial-temporal portal, G-World is the Fortress World that stands guard to ensure order remains in MetaCosmion and to defend MetaCosmion against attacks from the dark Forces of Evil. Extremely skilled experts with extraordinary mental capacity work in the Guardian World.

MetaCosmion (also, short form: MetaCosm) is the SuperUniverse that encompasses an infinite number of worlds. Among them there are cosmos-universes and chaos-universes, where cosmos (i.e., an ordered world) either was not yet born or was transformed to chaos by an invasion of the Forces of Evil. In some remote corners of MetaCosmion, Time Flows endlessly cycle: the world periodically perishes and revives in precisely the same form and the Past returns repeatedly.

Guardian World Practical
A Diary Recorded by Jason Skysmith, ChroMec Class of 2339

1. A Voyage between Two Worlds

June 23. This morning, I boarded the ARK OF JOY. A ship like none I had ever seen before in any of our ports, it's capable of entering the Guardian World — even though this area is generally inaccessible to ships. During a thorough tour of the ship, I saw Chris Brandon, a pal and classmate from ChroMec. He's also doing his practicals now. We were relieved to see each other and stood on the deck commenting about how surreal it all feels. We wondered: will we really take part in such a remarkable occupation? Will we be able to perform the crucial work of maintaining the Universal Time Order in all of MetaCosm? And, how soon could we actually become members of so mysterious and prestigious an organization as the Corporation of Chronomechanics?

First, we'll have to succeed in our practical work in the Guardian World, which I'll record here. My teachers at ChroMec all warned me that practicals are where the real chronomechanics are chosen. If you don't succeed during practicals, your career as a chronomechanic ends before it even begins. I'm glad Chris is here.

Entering the Space-Time Fold

June 27. Chris and I were listing all we knew about G-World. Crossing the border into G-World means we'll sail the waters of El Zagrado Sea and disembark on Zeno Island — the center of the Guardian World. Besides Zeno, El Zagrado includes a chain of smaller islands that make up the Islands of Archipelago. Zeno Island is where we'll begin our practical work. Once on the island, we'll observe the most essential events of MetaCosm's natural history: birth and death of the worlds, creation of living matter, birth of stars populating the sky, etc. We'll gain unique experience, acquaint ourselves with the workings of Time and Space mechanisms, and help defend against the Forces of Evil. Certainly, our future work includes performing various practical tasks with success. Only after proving our abilities to undertake these tasks will the High Council of Chronophylaxes certify us as fully qualified chronomechanics.

2. Inside the Guardian World: First Impressions

Arrival

Chronophylax

June 30. Today, after seven day's voyage, we landed on the soil of Zeno Island and proceeded directly to Philopolis City, the G-World capital where both the Control Center and the Administration of Time and Space are situated.

Supervisor Chronophylax Adrian the 14th met us at Mundi Harbor. We were very flattered, particularly since we knew from our classes that chronophylaxes, the Guardians of Time, are the highest officials in the administration.

His robust greeting, "Welcome to the Guardian World!" was followed quickly by, "my assistant will show you to your rooms. Make yourselves comfortable and have a rest. Tomorrow, we'll discuss our future work." Some may have thought him abrupt but I just assumed the Guardians are so aware of time that they don't waste any of it. Our quarters were only a short walk from the Control Center.

It was a rare treat to get to see the Center my father had been so involved in designing as one of the main architects of record. I saw the blueprints many times, but the actual building impressed me in a way that the blueprints never could.

Next day, at exactly 8 A.M., we arrived at the Center. Its interior was equally impressive. "First, you'll get acquainted with the Islands of Archipelago," the Supervisor informed us. Again, his description was brief. "Next is your practical work, then you'll be given a test of your abilities. Today, is your tour through time. You may pick the point we start at," he said without wasting a moment.

"The beginning!" we exclaimed unanimously. "Let it be the Beginning of the Universe," I shouted, "if possible!"

"Possible?" smiled the Supervisor. "It's only a know-how. Our powerful time flow synthesizers will allow us to descend through the time scale directly into the Primary Chaos."

Birth of a World

July 1. The Supervisor led us to a special viewing tower situated on the outskirts of Philopolis City — an excellent place to observe the world being born and a safe distance away from the violence of the event. Feeling just like chrononauts, we watched an amazing spectacle. A Cosmic Egg was laid by a huge bird into the formless primeval ocean. From this, all of our universe would be born. It was just as so many ancient myths describe the birth of the Universe.

...Bbbang! The giant egg exploded, splitting into two halves. We watched the sky and earth forming out of them, with the yolk producing our Sun. At the time of this entry, many hours after the start of our time tour, the newborn Sun still hasn't taken its final shape yet. Shreds of primary matter continue to stream from the burning sphere rising over the ocean.

Inside the sphere, Heaven and Hell mixed together! As the terrible heat emanated from the center, the Elemental Flame was unbearable.

Saturn Babies

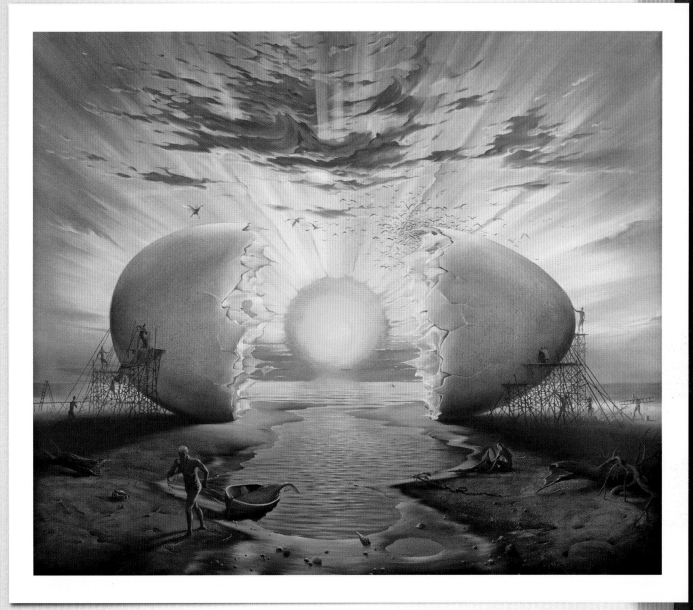

"*Primeval light shone as bright as ten thousand suns.*" So says an ancient Indian poem about the action of an unknown weapon, used once in a battle of nations. We posed several theories, but couldn't figure out how life could be born from this heat.

Tunguska Meteorite —
Primeval Element of the Universe

After Millennium Battle

Time
Management
Officer

July 2. The next time object we examined was a huge, old-fashioned alarm clock positioned in the middle of a vast desert plain. It carried a strange name — the Millennium Guardian. Standing firmly at the top of a ladder, a master technician in a blue robe fixed the clock mechanism, which we were told had been heavily damaged in recent battles against the Forces of Evil. "What if he suddenly turned the clock's hands backwards?" I asked Chris. "Then, would all events move backwards too?" My eyes did not leave the master's work.

"Now, that's something!" he responded, happy at the thought. "Do you think we could see the Battle of Hastings, knights in their shining armor and all?" Chris was a medieval English history buff, and the pivotal Battle of Hastings was as real to him as his classes at ChroMec.

"I think it would be great to have such a small clock," I admitted. "Just press and events go backwards! I wonder whether anybody has looked on the other side of the Clock?"

"They say yes," said Chris, "and there is only one hand there. It shows millennia."

"Well, then it moves very, very slowly. What if the Master stopped the hand?"

"Time would stop, too," said Chris. "Oh, no!" he realized, "we would always have breakfast and never again see dinner." Chris had a sweet tooth and dinner at ChroMec, which was usually followed by a rich dessert, was his favorite meal.

"Well, that would be a pity," I said, "but in fact we wouldn't have time to get hungry!"

Overhearing our conversation, the Supervisor smiled. But we were soon interrupted by the arrival of the CEO, or Chief Eternity Officer, who was on an inspection visit to the Plain of the Clock. A tall man with a piercing look, his gold medals of distinguished service shone in the sunlight.

"He's one of the most decorated scientists in history," Chris whispered as we watched. The CEO performed his inspection with military precision as his uniform flapped gracefully in the strong breeze.

"This legendary person," said the Supervisor, "has been leading the Administration of Time and Space for more than 100 years." We greeted him with great respect.

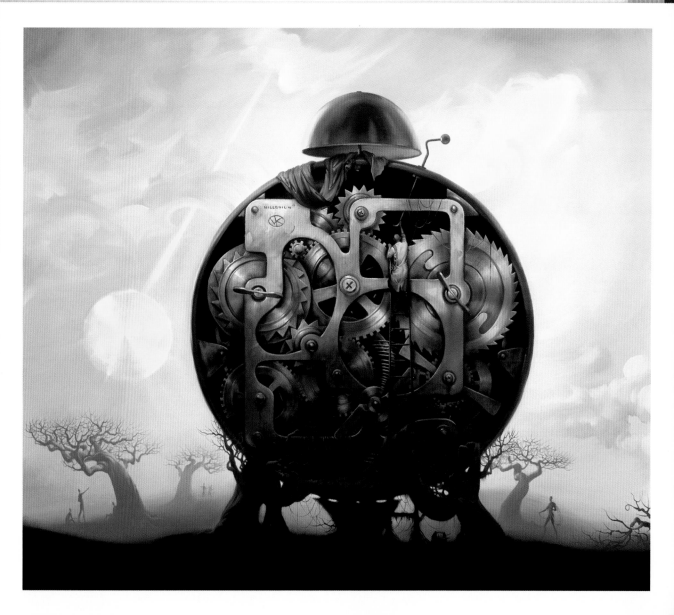

"Everything is not so simple here," he explained, looking at us with interest. "Now you see the routine work of our chronomechanic, but it was far from being quiet here quite recently."

The CEO left us to tour the Clock, while the Supervisor elaborated with major facts and events involving the Great MetaSpace War that has waged for several millennia.

"Can you name the Leader of Evil?" the Supervisor asked.

"Lucifer," I said, without even stopping to think.

"He has many names," explained the Supervisor. "Lucifer is actually one he does not like because of its history. It was a saint who first gave him the name Lucifer while translating ancient texts. For evil to be named by a saint — well, you see such evil could not abide by that. Besides, Lucifer has another meaning as the light of the morning and refers to particular star. Can either of you guess which one?"

"Venus, the morning star?" pondered Chris.

"Quite so," he continued. "Venus is visible in our early morning but quickly sets. When St. Jerome gave The Evil One that name about four centuries after the start of Christianity, his allusion was that Lucifer was the brilliant angel who quickly fell from grace. This reminder of failure was not what The Evil One wished to use to refer to himself."

"But, you said he has many names," pressed Chris. "What of his others?"

"He is also called the Prince of Darkness, Emperor of the Dark Empire, Satan, and so on. Each culture and language has given him their own names. I could spend a long time listing all of his titles! You are both wise to remember that evil appears in as many forms as it has names. Many centuries ago the Leader of Evil tired of being named by others and bestowed a title upon himself in the hissing sounds of evil. The closest approximation to this sound that humans can make is Ferevoulf, and that is what we call him here at the Center. Ferevoulf reigns over the Worlds of Chaos and Eternal Return, and is anxious to expand the borders of his empire by force and cunning. From his cosmic capital of Demonopolis, he and his followers are relentless in their attempt to conquer new worlds and then cyclisize – or even completely chaoticize – them."

"What does cyclisize mean?" I asked.

"Time will go in a circle," said the Supervisor, "and whatever happened before will happen again. You may have studied this as a closed time loop."

Tracing the Flight Path of the Arrow of Time

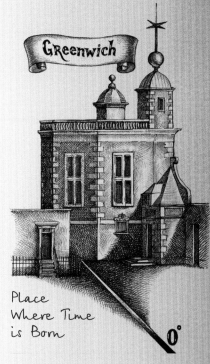

Greenwich

Place Where Time is Born

0°

I had a hard time understanding cyclisization. "But where is the danger," I asked the Supervisor, "of Time going in a circle? A clock hand makes a complete circle and nothing terrible occurs."

As we entered the Center's Time Control Room he asked, "have you seen the Arrow of Time on our Universal Computer's display?"

We nodded.

"When time is cyclisized, the beginning and the end of the Arrow will be tied together into a terrible, vicious circle, and Evil will never disappear from the world. To sow the seeds of death and destruction, Ferevoulf has been using Dark Matter — shards of primeval chaos that he hid in space caverns after the birth of the Universe. The attacks of the Forces of Evil have become more intense lately, particularly after the end of the last millennium."

"We heard that they used the newest, most sophisticated kind of weapon in the last great battle," said Chris.

"Right," confirmed the Supervisor. "Those weapons were real time crunchers! Often, the celestial mechanics seemed not to stand the test. Linear flight of Arrow would stop and turn into chaotic movement. But then, through the cleverness of our chronomechanics — some not much older than you two — the enemy was defeated and expelled back into the Dark World.

"Nevertheless, Ferevoulf's crafty plots have become more refined. Our chronophylaxes have needed to expend a supreme effort to neutralize them. Day and night they keep watch at the universal displays, tracing the flight of Arrow and preventing the enemy from disturbing the integrity of our Worldwide Stream of Time."

Perhaps, I thought, some day I'll also take a place at the display to guard the Timestream. Coming out of my daydream I asked, "Is the Arrow moving on the display a real thing? Can we see it flying somewhere through Space?"

"Certainly not," answered the Supervisor. "Time's Arrow seen on the display is only a reflection of the mighty universal stream of chronons — the tiniest particles of time.

Just like a sensitive compass needle, it shows the direction of chronon flow, in which we all are submerged. No one can leave this flow."

We stood for a while at the display. Examining a city above which the Arrow was moving, we realized it was Philopolis.

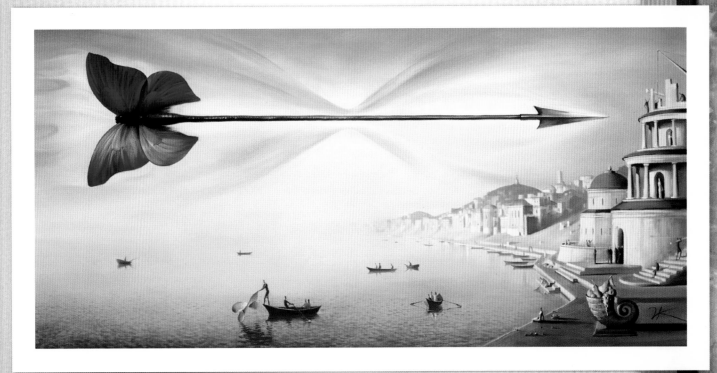

Editor's Note:

The Forces of Evil used to gather on the New Babel Space Plain for Semi-Final Battles with the Forces of Light.

Space Spider Site

July 5. "But not only Time needs our protection," the Supervisor was saying as we walked back into the Center. "A no less important task is to keep the integrity of Space in which we all live. Ferevoulf, in his rage and madness, wants to loosen this basic structure of Cosmos too. As your Supervisor, I should acquaint you with the working of MetaCosm's most important builder, the World Spider. To do so, I will put you both, for a while, under the supervision of my friend and colleague, Space Guardian Adalbert the 4th," he concluded.

In the afternoon, Adalbert led us to the impressive Tower of the World Spider.

"The Spider 'spins' space strings that form the skeleton of the MetaCosm body," he explained, as we got inside. "If it stops spinning strings because the Dark Madmen disturb its work, the Universe will lose its framework and collapse, turning into an absolutely plain Flatland."

"Perhaps then our world would look very much like a huge sheet of paper," said Chris, thinking out loud, "and we would transform into simple-shaped creatures living among geometric lines?"

Before I could try to figure out the answer, I suddenly had the distinct sensation of someone staring at me. It came from the black icy depths of Space. Then, I felt a strange piercing cold.

Beethoven Gramophone Universe

Universe Shaped Like Gramophone

2326 April 21. The universe has the shape of a gramophone, not a soccer ball, as thought earlier. As reported in *New Scientist*, scientists using computer models concluded that one end of the universe is shaped like a narrow pipe and the other is crowned by a wide bell. This major finding proves that the universe is finite and explains why time and light are so deformed in some locations that a researcher can see the back of his head without a mirror.

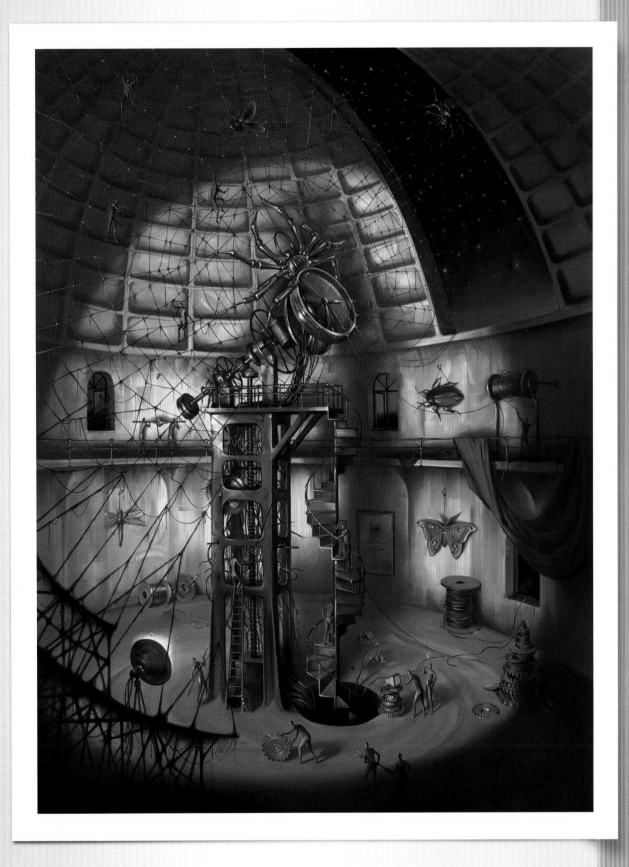

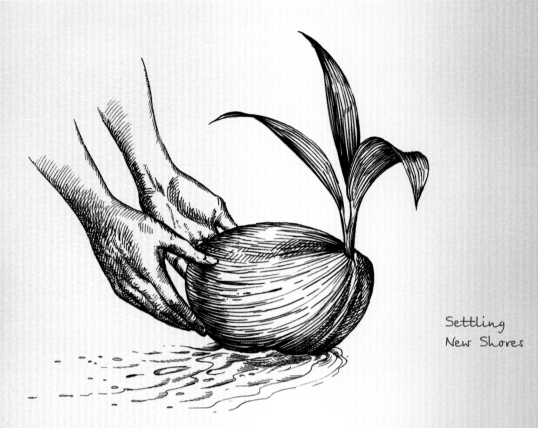

Settling
New Shores

3. The Voyage around the Archipelago

Bon Voyage!

July 6. After Adalbert revived me, I learned that Chris had experienced the same odd sensation, but to a lesser degree. Adalbert thought that we might have strained ourselves by seeing so many uncommon spectacles at once. This strain produced a type of space-time sickness, common among visitors new to the wonders of G-World. As a curative, our Supervisor recommended making a small voyage around the Islands of the Archipelago.

"To expand your time, or historical, horizon would be very useful for you future chronomechanics," he said. "But you shouldn't only look at people and events of the past like researchers in a laboratory. Here you can feel the spirit of those remote times with your very own skin and muscles. The best way to experience this is to take a trip outside of our time and become crew members of an ancient ship such as this one, the CORAL CARAVEL, which makes regular voyages between the islands in the Archipelago's historical zone. This physical and psychological training will show you what it meant to be a man of those times — especially when you stand against the raging sea in a fragile vessel. So, bon voyage."

Glad Clipper
Arrival

Caterpillar Path

July 10. The first island we visited was Eden. While walking through Genesis Park sightseeing, we found our way to the Garden of Eden and immediately wanted to see the famous Tree of Knowledge. I wrote this entry while standing beneath its leaves and looking at the shiny, green apples hanging down almost to the ground. The earth around the Tree was dotted with fallen ripe apples. Out of them grew magnificent flowers, which came to life now and again to fly up into the air.

"So, these are butterflies!" guessed Chris, "But they usually flutter above flowers and not out of them, don't they?"

"Let's try to look at them through our achronomatic binoculars," I proposed, puzzled.

We stared at the apples through specialized binoculars that made Time run faster. And in this greatly reduced time interval we saw a small, hairy caterpillar making its mysterious way into the apple — an event unrecognized without the aid of the achronomatic binoculars — and, little by little, transforming into a butterfly. A quivering wing appeared outside and, finally, the butterfly itself appeared.

It was wonderful to see this! A wind gust caught it and, fluttering, the butterfly flew away. But in no way did this prepare us for what we soon would see — butterflies catching the wind, acting like the sails on a ship!

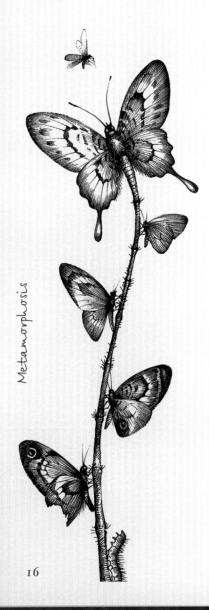

Metamorphosis

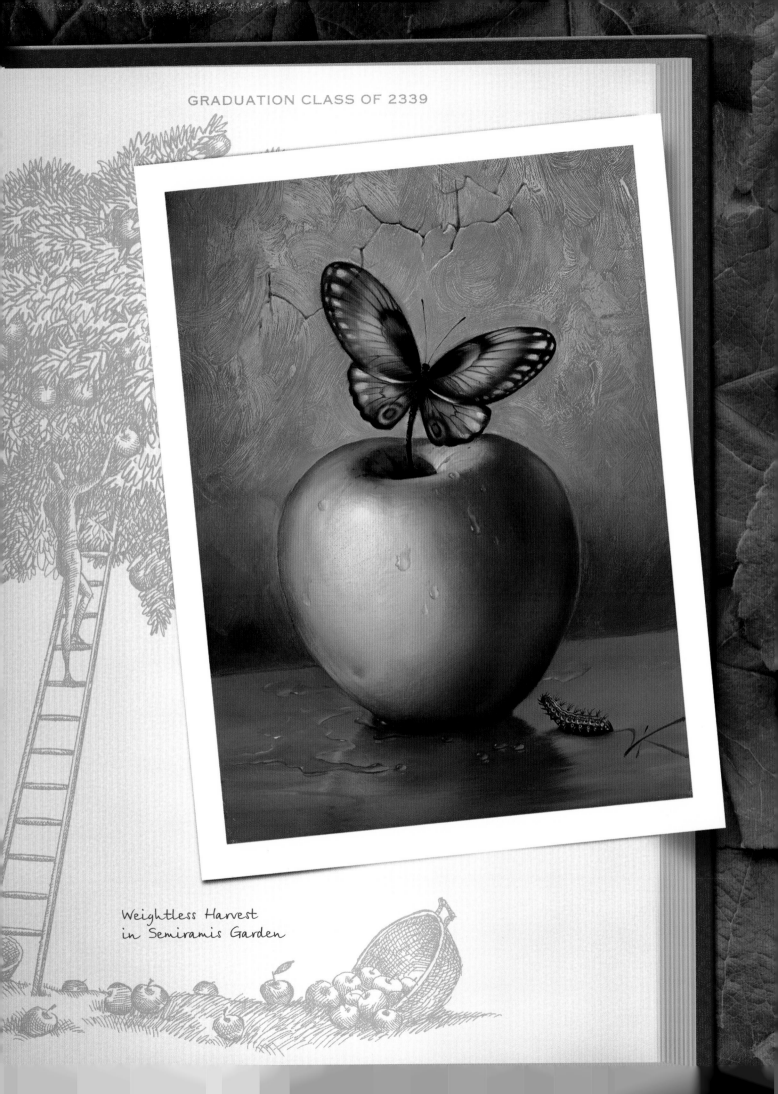

Weightless Harvest
in Semiramis Garden

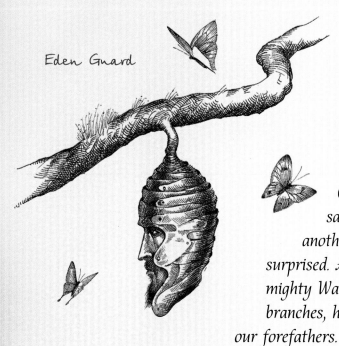

Eden Guard

Inside the Nut of Eden

We had hoped to meet our ancestors – Adam and Eve – somewhere near the Tree of Knowledge. However, the Garden Inspector who accompanied us said that they are more easily found near another tree. "What other tree?" we asked, surprised. A bit puzzled, we followed him to a mighty Walnut Tree. Here, beneath its great branches, he told us what had really happened to our forefathers.

"You certainly know from the Bible that Adam and Eve were advised by the Serpent to eat a forbidden fruit from the Paradise Tree, which is also called the Tree of Knowledge. But the Book of Books doesn't tell everything! Threatened with expulsion from Paradise, they decided to hide from the eyes of the cherubs who act as Paradise guards, and wait until the anger of God would diminish. But where could they go? The all-seeing eyes of cherubs were everywhere!

"So they had to resort to aid from the same Snake. Using his magic skills, he reduced them in size and hid them in the shell of a walnut hanging on this Garden tree. Sealing the Nut by a magic letter-key, he made the pair sitting inside invisible to the cherubs.

"And now, try to guess what letter he used to seal up your forefathers. As a prize you'll take a small trip inside the Nut," said the Inspector.

"Certainly, this letter would be Hebrew!" we both exclaimed, knowing that Genesis was written in this language.

But all of our knowledge of the Hebrew alphabet has been limited to the first letter – Aleph. I vaguely remembered a story told by our teacher of MetaHistory at ChroMec. He spoke to us about an amazing ancient word – Olam – in which the meanings of the words, "world" and "time" merged together. It meant something like World Time, or Time World.

"What if it was the letter with which the word Olam begins?" I asked, even though I didn't know its name.

"You have guessed right!" said the Inspector, "and that's surprising. It's a rather unusual letter – Ayin. Now, few even know how to pronounce it."

Starting up the necessary lilliputianization program, he reduced us in size and placed us inside the Nut. Getting inside, we realized that its walls were completely transparent from within but not from outside. It was a thrill! We felt as if we were hovering in the air.

I also should mention that the prize from the Inspector not only included the trip itself, but the precious computer program that made it possible.

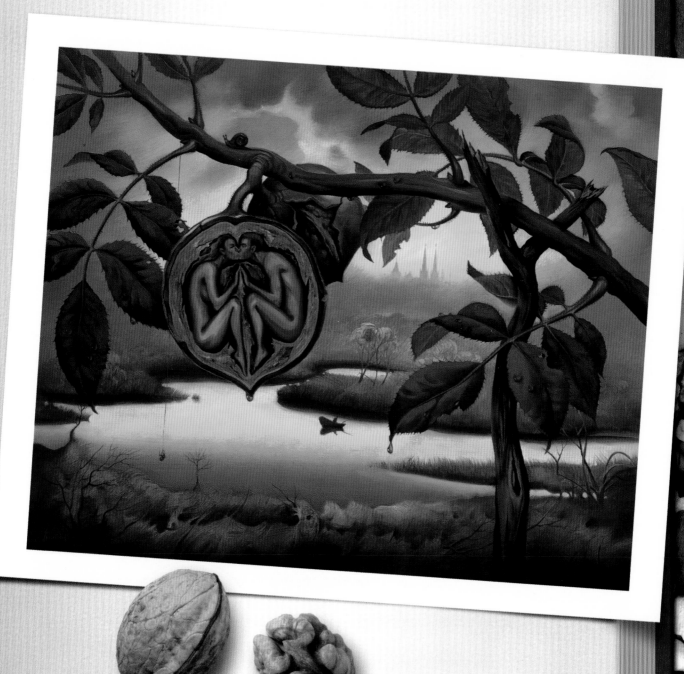

Freeing the Prisoner

Winged Voyage I

July 12. Just like Adam and Eve, we absolutely didn't want to leave the Paradise Garden, and, perhaps, to get out of the wonderful Nut. But Chris, never forgetting the real, not the Nut time, brought our duty back to mind. "Jason, other wonder islands await us. We are crewmembers, aren't we? By now, the CARAVEL *and its command are ready for departure."*

Having collected a whole bag of wonderful apples capable of turning into butterflies, we rushed back to the sea.

Amazingly, butterflies followed us to the ship anchored in the bay. Then, they covered the masts, and we watched them grow until they, and those from our bag, had transformed into sails!

"But what caused this miracle?" asked a bewildered Chris.

"Probably, we are to blame," I surmised. "Our achronomatic binoculars, besides accelerating the flight of time, seem to stimulate enormous biogrowth!"

We knew that butterflies very much liked traveling aboard ships as passengers without tickets. But, butterflies moving a ship — that we couldn't have imagined in any way. Winged CARAVEL *was an unprecedented, magnificent ship, shining in all the colors of the rainbow!*

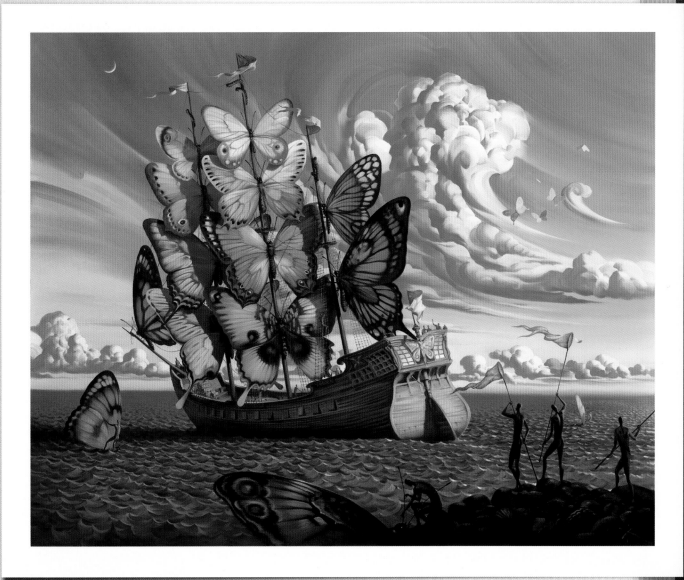

Turtled Planet

Millennium Shuttle Turtle

July 14. On the way, we visited another unusual island. Approaching it, CARAVEL nearly ran aground on a rocky sandbar that was sticking up out of the water. Having doubled back to it, we saw a round islet divided into strange penta- and hexagonal areas. There were lots of people on it.

"Why, it's a Millennium Turtle!" the captain explained after taking the helm himself. "We have now entered the aquatic zone of huge turtles, giant prehistoric sharks, and dangerous sea snakes. Beneath us there are extensive underwater forests and ruins of seaweed-covered ancient temples and palaces — Southern Atlantis, say the archeologists — where these creatures live. But this Turtle has gotten used to dozing at sea surface. Basking in the sun, it appears to remember those times when it was a young Space Turtle floating across the sky."

"So the rock against which we nearly ran aground was its head?" I guessed.

"Yes," confirmed the captain. "Unfortunately our young helmsman hadn't known it and the ship might have been wrecked. Ancient annals say that once every 1,000 years the Turtle wakes up and dives toward the bottom of the sea to visit her relatives."

"These people might intend to settle on this alleged island and don't at all suspect a danger threatening them," said Chris.

"I've already given the order to warn the people on Turtle Island," said the captain, "so they should understand, at last, on what unsteady ground they stand!"

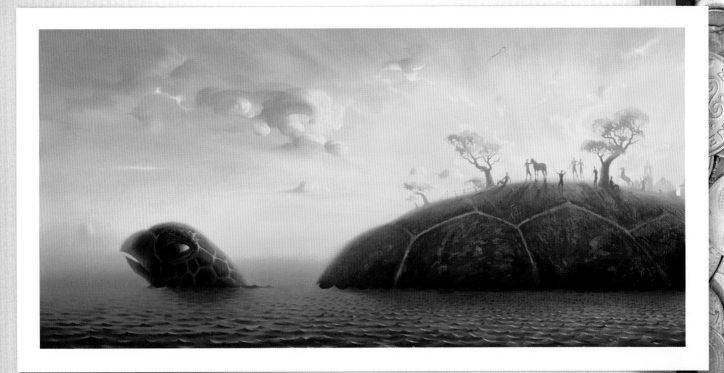

"I hope they wouldn't build a fire here!" said Chris. "The Turtle would certainly dive under the water to put it out even if it is before the end of the millennium. There's a story of an ancient mariner, it was many centuries ago in real time: People from a ship built a fire and cooked food on the back of a huge fish, having taken it for an island! That sailor – Sinbad was his name – barely escaped," he said. Chris spent most of the journey to our next stop entertaining the captain with his knowledge of history and mythology.

Catching and Grazing on Llama

July 16. Finally, we arrived at the island designated on the map as Llama. We expected to see high mountains — the type of terrain where llamas were known to live — but only saw a plain burnt by the sun, bare and deserted. On this plain, we saw a strange person armed with a huge butterfly net. Nearby, his horse — which he had apparently forgotten because he was so absorbed by his hunting — grazed about. This horse was quite unlike a llama.

"It's Don Quixote himself!" exclaimed Chris, "and his horse Rosinante! But where are the llamas?"

"Aha," I said. "Llama Island isn't at all a place where lamas graze. Its name must be an abbreviation for La Mancha — Don Quixote's native land in Spain. Over the years, LaMa must have come to be written on maps with its current spelling, the sound-alike of Llama."

"Why, he doesn't realize, does he? Is it possible to catch such butterflies in his net?" exclaimed Chris, astonished.

"Remember him fighting windmills?" I asked. "He is always about to undertake the most impossible tasks. If only I could talk to him!" Perhaps, I would be able to do it without using the transcom. You know, Chris, I could try talking to him in Spanish. I used to talk with the Spanish-speaking guys on our football team at ChroMec. ¡Buenos dias,

Steering Wheel for
Quixote Lord of Wings

Señor! ¿Usted gusta jugar al futbol?" Chris sobered me a little. "At ChroMec you were taught the first rule of Chronomechanics, weren't you? Never leave the Safety Path, never talk to anybody in that world. Otherwise, a chain of events could transform our world so that you wouldn't recognize it. Or, you could transform yourself into a Golem or some other horrible creature! There are reasons for the rules!" he warned.

Don Quixote could neither see nor hear us. In fact, we were outside of his Time. Besides, he was too absorbed in his pursuit, and the faithful Rosinante was far away. We couldn't remain on the island for long. Other miracles awaited us. It was rumored that in the eastern part of El Zagrado Sea on Syrochaldea Island, a scientist using a telescope of unprecedented power had located an ASTROTYRANNOSAURUS. *This news spread throughout the whole Metagalactic World.*

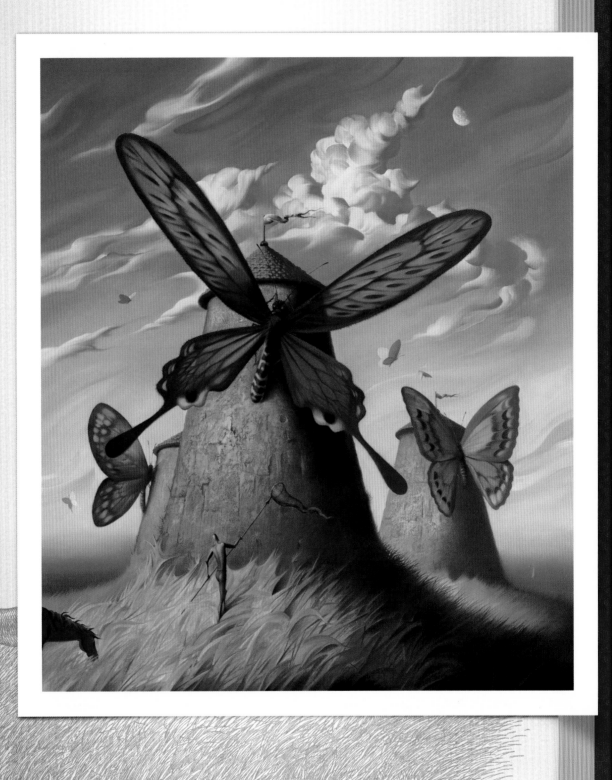

Astronomic Safari Invitation

July 16. We found the Star Gazer pressing his eye against his gun-telescope. He wore a bluish dressing gown with a metal shine to it and had a narrow beard like an inhabitant of the East from ancient times. He was aiming at the region of Very Deep Fields, that most ancient area of the Universe discovered earlier this century by the Hubble-3 Space Telescope. "Just look! Astrotyrannosaurus!" he said, consumed with the greatest excitement and passion. "I swear by MetaCosm, the Great Caliph of AAB will be pleased!"

Even before we were introduced, Chris recognized the Star Gazer as the Great Caliph Haroon the 18th. The Star Gazer was downright overjoyed. He said that in his whole life — almost 200 years — he hadn't met such star game. The fact that this creature had eluded him was made worse by the text of ancient chronicles. It was written that in ancient times, the Bloody Red Room of his palace — the same room from which he was observing the sky now — was decorated with a curious hunting trophy: a star cuspid of this fantastic beast.

But the Corporation of Space Hunters believed that Astrotyrannosaurus had died out long ago and now the fields and lakes of space were populated only by well-known Capricorn, Taurus, Pisces, etc. His theory was that the Very Deep Fields preserved the space fauna of antiquity.

"Certainly," contemplated the space hunter, "It's possible to organize the hunting of Star Saurian from here. However, inaccurate shots threaten to create an increasing number of black or, depending on the type of weapon, red, green, and especially dangerous dark blue holes in the hull of our Ship of the Universe that floats in MetaCosm."

"Surely you wouldn't kill such a rare beast for a trophy!" Chris blurted out before I could stop him. Diplomacy did not come naturally to him.

"Heavens, who said anything about killing it? We must study it. Perhaps breed it. But first, we must catch it. So, it's time to get closer. Make preparations for a space expedition!"

Chris and I exchanged looks — the prospect of going to an unknown corner of MetaCosm to hunt was very enticing.

Stone Age Safari

26

"Friends," said the Star Gazer, "we need the young people of your kind. Join the Hunting Corporation!" he concluded, looking at us hopefully. It was tempting, but we are students with lots and lots of work and a different future already ahead of us that is even more exciting and rewarding. It was time to finish our Archipelago tour and get back to the Center.

Editor's Note:

Space Domain AAB includes star fields Al Debaran, Al Tair, and Betelgeuse. The Great Caliph is the Guardian of Time Stability in this area, and space hunting is his hobby.

4. Forest of Wonders: The First Trials

Time Seen through Black Portholes

August 17. *For the past month we've worked in the Control Center, honing our knowledge and sharpening our time-control skills. Our days have been long and required a great deal of work to keep up with the assignments given to us by the Supervisor and his staff. There's been no time to record events in this log.*

How much new information we've learned! And how many riddles conceal such a simple thing — Time! For example, we've gotten to know that in the red holes of the Universe, Time flows backwards, while in the green holes it disappears alto- gether. In the Time Flows that stream through dark blue holes, waves and ripples constantly form. Especially great danger arises when these waves and ripples splash out to other star worlds. We worked in a special group that was solely tasked with emergency management of this problem.

But the most amazing thing is the behavior of the black holes! The writers of the Bible seem to have penetrated the true nature of our Universe. In black holes there exists that Time-World Olam that we learned about at ChroMec. Time there, like Space, has three dimensions: length, width, and height. It's hard to compre- hend, but a proven scientific fact nonetheless. More exactly, black holes resemble the portholes in the hull of our Ship of the Universe through which we can see the Ocean of Time-World, which scientists at the Center have named METACHRONION *and call* METACHRON *for short. At the Control Center, we were able to monitor signals from space stations located near a series of black holes. This allowed us to use our miccomps (which is what we called the microcomputers at school) to model a journey on the edge of Time Ocean, along the line of space-time zero cur- vature. Amazing trip!*

August 18. *After "returning" from our virtual journey, we discussed what we had seen in the three-dimensional space of Time.*

"It seems that the Ocean of Time-World we call MetaChron is filled with events that could have occurred in our world, but did not," I said.

"What do you mean?" Chris asked. "Do you think that things are not just out of time but contain alternate realities?"

Monsters of Dark
MetaChronion

"Definitely. For example, if I were born a couple of years later, we probably would not have become friends and would not be here having this conversation right now. Or, even if I had been born on exactly the same day, we could have been sent to do our practicals in different places. MetaChron stores these alternate versions of our lives, probably in chains of events."

"But so many life versions would be infinite!" Chris exclaimed. "That's not possible."

"Perhaps possible, but not likely," I said.

"What has you so convinced?" asked Chris.

"I saw both of those alternate realities for me while I was at the time displays in the Control Center," I said.

"No way," said Chris. "I never saw myself while at the displays — but if what you're saying is true, that's an incredible number of variants just for you."

"Not only are there variants for me, but there are different life versions for every person. And not only for humans, but for each sentient creature in the Universe."

"And they all 'splash' there," asked Chris, "in the Ocean of MetaChron?"

"According to what I saw, they do."

We stopped, impressed by the incomprehensible grandeur of this picture.

"Is MetaChron really capable of containing such an enormous amount of data?" Chris asked.

"I don't know. There are many extremely complicated questions here, and the study of MetaChron has just begun."

"Consider this," said Chris, "If you got stuck in a time loop, you could meet yourself — or at least your same self from a different time. If you got stuck in MetaChron, you would face the possibility of meeting a great — or even an infinite — number of yourselves. The first several might be almost identical to each other, but each version would be more and more different from your original self."

"Until finally you might meet yourself but you would not be yourself at all," I said, wondering if he had followed my convoluted logic.

"Yes, but how would you recognize that you were actually you?" Chris asked. "If MetaChron is all about the different versions of reality that are possible when one makes a choice, then it is a vast catalog of what lies down the path beyond the other fork in the road that your original self rejected — and all its implications. What if your double chose to change the color of his eyes or to shave off all of his hair? In fact, even if you saw yourself, you might not realize that you were looking at yourself!"

We plunged into thought and explored this concept. Indeed, how could you recognize yourself? Generally speaking, what makes us who we are — a collection of physical attributes or something greater? Where does personality begin and end?

But here we discovered an even greater question: Are all worlds stored in MetaChron real? Or is our reality the only true MetaCosmion? All the same, it would be great to travel through the oceanic labyrinths of MetaChron getting acquainted with our countless incarnations!

Neutralizers for the Dangerous Wonder World

August 20. Our intense work at the time displays is complete. The Supervisor, our much-revered guru, was so pleased with our progress that he suggested we continue becoming acquainted with Zeno Island. After a hearty meal and a short rest, he took us to a botanical garden.

"Here, my explanations are unnecessary!" he said as we arrived. "I want you to see more astounding miracles — but take care. The world of wonders conceals many dangers." With that warning, he gave each of us a Neutralizer of Dark Energy, a device made from rhenium that looks like a badge in the form of a snail shell with a small pearl in the center. Touching the pearl would switch it on and allow us to eliminate the attracting and destructive influence of Dark Energy for a short time.

"You must not forget that most important task," added our guru. Switching on the neutralizer was easy during training, but a whole different matter when under the actual influence of Dark Energy.

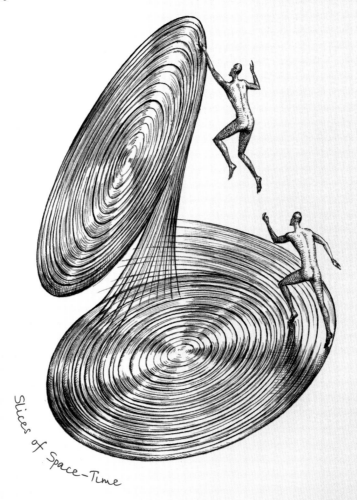

Slices of Space-Time

Dance Creating
the Universe

Rose-Turned-Rosarosa

After getting these pointers, we went along the path through the garden. As we walked, Chris and I discussed what dangers the Supervisor might have meant. After a hundred steps we stopped in amazement. On a stage, surrounded by human-sized plants, real flowers were dancing, twining together to form beautiful wreaths. We joined the other spectators.

Everyone was waiting for the entrance of a well-known scarlet flower, Rose. Once on the stage, Rose swiftly whirled in a magical spiral dance. She blossomed out as a magnificent flower, then — in an instant — rolled back into a tightly closed bud. The dance grew in intensity, its rhythm becoming more and more furious by incorporating the magical energy of the bewitched garden. And then, a miracle happened before our eyes: Rose transformed into an equally beautiful girl named Rosarosa.

"They say that after finishing her dance, she turns into a flower again," said Chris who was reading an old program he'd found on the ground.

"Just think," I said, mesmerized, "only while dancing can she retain her human form. I wonder whether these flowers," I pointed to the flowers all around her, "are also girls-turned-flowers?"

"And the spectators?" mused Chris. "Are they flowers-turned-girls?"

We burst out laughing, but then suddenly felt sad as we realized that, once bewitched, the girls are doomed to remain flowers. We speculated that the Forces of Evil had some involvement in this process. The violent music of the dance gradually calmed down and was replaced by the sounds of some stirring melody from far away. We answered its summons and went on. The garden became thicker until it turned into a dense forest.

Forest on Record

August 21. Under the arches of the forest we heard a symphony of usual voices: singing birds, the breeze through the trees, the rustle of grasses, that knocking sound a woodpecker makes, and something else as well. There started to play another, highly unusual music. We followed the sound to a glade that was sheltered from view. Here, stood an ancient gramophone beneath a large hanging bulb. A unique stump-turned-record rotated on the turntable revealing that its annual tree rings actually stored a great amount of recorded music.

A voice emanating from the bell-shaped mouth of the gramophone declared, "Hypersymphony: The Life of a Forest!" After this announcement, we heard those barely audible mysterious sounds of a forest being born from the seed thrown into primeval chaos. Clear sounds, similar to a roll call from thousands of pipes, followed. These were the centuries of the forest's childhood and youth. Then the roll of huge drums announced the millennia of maturity, struggle against the elements — lightning strikes, droughts, floods, tornados, and hurricanes. And, finally, death was pronounced through the mournful voices of a forest requiem.

The next track of this unusual concert recording that we stumbled upon was a cantata that the voice announced to us as, "Rain Forest is our Savior." I personally liked a later, more choral work that was called, "Nightmares in the Malagasy Forest after Dark." It was something! The chorus of the night monkeys shook me to the innermost chambers of my heart. As for Chris, he went into ecstasy over the brass band masterpiece, "Ole Green Wood Marching On."

Forest Tuner

Music of the Spheres

2005 December 14. Landing on the surface of Saturn's moon Titan, space probe Huygens broadcast music as a human message to potential extraterrestrial life. The music will continue playing while Huygens performs its primary mission: finding clues to Earth's past. Scientists hope the probe will see Earth's frozen past in Titan's atmosphere, which resembles Earth one billion years ago.

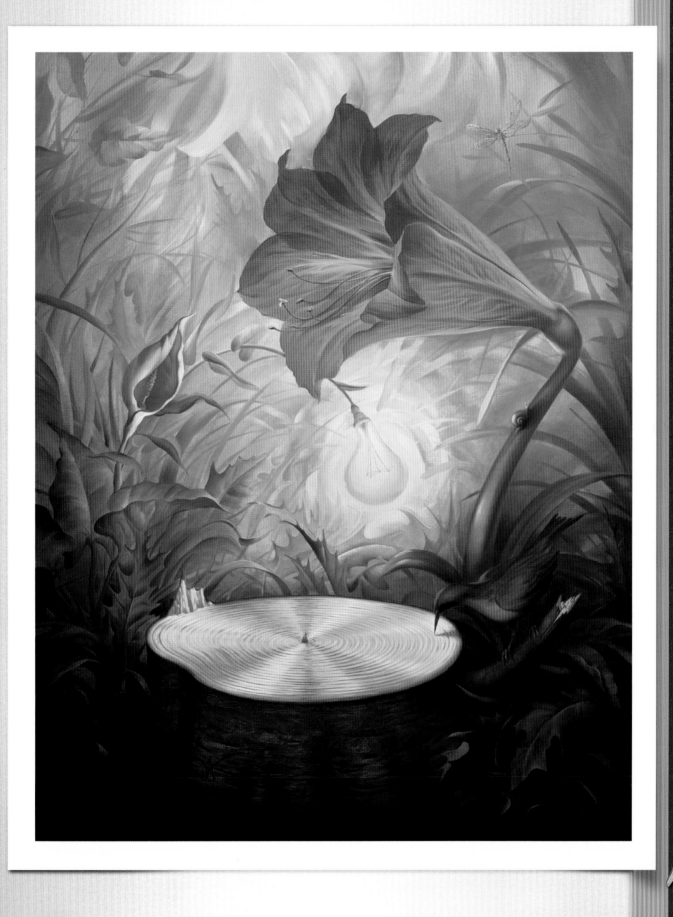

The One Who Came
from the Murky
Transgenetic World

Cellist in Dark Flight

"Look," I said, tapping Chris on the shoulder, "here comes a musician! I won't be surprised if I learn that he's the composer of 'Nightmares' on the forest disk."

An impressive, but eerie, picture opened before us. In the thicket played a cellist dressed in black. He looked like a being from another world. Like the great ancient violinist Paganini, our Maestro appeared to enter in alliance with the omnipotent Forces of Darkness and spoke in that superhuman language of butterflies, bees, beetles, and grasses.

Carried away by the music, we watched him with bated breath.

"Do you like this tune?" asked Chris quietly.

"Well, I don't know," I answered, "It's rather unusual, but also, I would almost say, well — devilishly divine."

At that very instant the cellist looked up, as if he had been revealed. Although we spoke not above a whisper, he clearly had heard us. Not in vain was he friends with those forest inhabitants who hear the slightest rustles and sense barely perceptible smells! After playing a brief finale, he suddenly turned into a black beetle and dissolved into the musical harmonies of the coming evening. His cello transformed into a butterfly and, flying upward, rushed from one exotic flower to another.

36

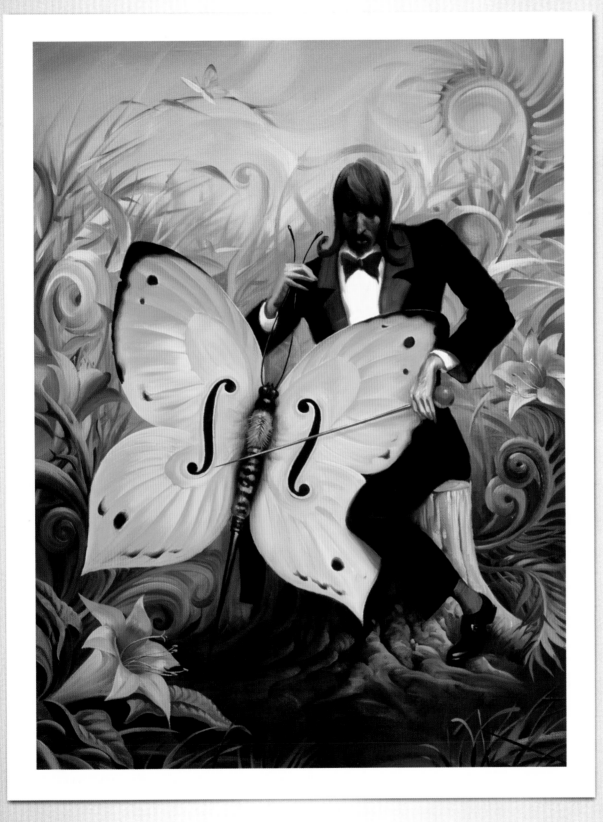

Unearthly Moon Well

Our infrared instruments allowed us to trace the path of the vanished cellist-beetle, and we rushed to pursue him. To our amazement, our bodies suddenly became lighter and lighter until we floated in the air. Daylight was waning as the Moon appeared. It began to grow until it filled half the sky.

Looking at this great disk, I didn't recognize the familiar lunar seas and craters.

"That's not our Moon," said Chris fearfully. "That's the Moon of the Other World."

Instead of a sensation of floating, we felt as if we were falling into an infinite black well. Above, at its edge, appeared a strange figure, which lured us. Where? We remembered the Supervisor's warning: Ferevoulf himself or his fellows will try to drag you both into the bottomless Well, Nada, or Nothing. Here, not only does a person perish, but all memory of him disappears from the world forever!

Moonlight is Ferevoulf's spectral path, the means by which he attracts naive and inexperienced people to his World. Feverishly groping for the button of the Neutralizer of Dark Energy, I switched it on and felt our swift slip into the blackness of the Well slowed until it finally stopped.

This incident worried us. As soon as possible, we had to get out of this bewitched place.

Mastering the Rings of the Past

Nero from the Tree

Evil
Unmasked

Apparently, the Dark Forces that accompanied the metamorphosis of the cellist had unleashed the spirits of the surrounding forest. Music ceased, and the muffled voices and distant commotion of a crowd became audible everywhere. It was getting dark.

Suddenly we saw the trunk of a huge old tree shining with a greenish glow against the darkness. Cracck! Its bark was drawn back like a curtain from which someone wearing a mask appeared. This specter came forth from the remote recesses of antiquity. In a shrill voice, he recited something in a language we could not comprehend.

"Let's switch on the transcom," offered Chris.

ANCIENT ROME - LATIN appeared on the display. We were horror-stricken as we heard the words of translation: "I am Emperor Nero! I am mourning my death! Look, how a brilliant actor is perishing! Oh, how I regret that I had not the time to set Rome on fire again and let the wild animals out on the streets! Then, not one of you miserable spectators could escape! It would be a splendid finale for the tragedy of my life!"

The unearthly green light streaming from the tree and the clothes of the infamous Roman reminded us that this villain watched cruel gladiatorial combats through an enormous emerald. The stone's green tint camouflaged the color of the blood that was spilled for his amusement.

Twin Nero Werewolves
Devouring the Moon

Colosseum Neronis in Flames

Here, as if in response to Nero's desire, the forest receded and we saw the ancient Roman Coliseum enveloped in flames. Not all of Rome was burning though, only the giant stadium Coliseum, or Colosseum, named in honor of a colossal statue of Nero (37 meters high, according to our miccomp) that once stood nearby. The most grandiose, bloody gladiatorial contests were held precisely here on this spot.

The Emperor suddenly stopped. Was he glad to see the flame and admired it? Before we could try to figure out his motivation, the hands of people ruined by Nero stretched out to him from the hollow cave that had been created in the tree. Hundreds of hands pulled him back into the black gloom of nonexistence or, maybe, into the eternal flame of Hell? We couldn't tell.

"Finita La Comedia — the comedy is over," we heard. A theater servant appeared on the scene and made this proclamation, at which point the spectators dispersed. We went away too.

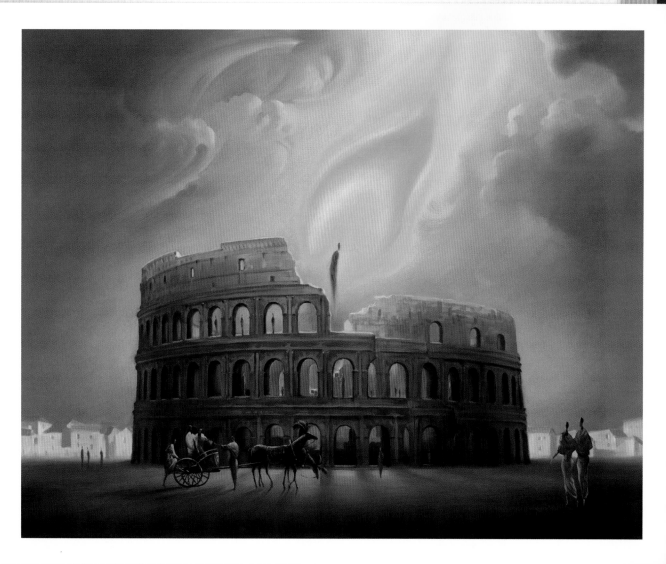

Contest at Coliseum

Mahogany Groan

August 22. We walked through the forest for a long time, trying to free ourselves from its many spells. The phantoms that had control of this place did not leave us, but re-tuned our instruments to keep us following false paths that would never lead us out of the forest. One hope remained: somewhere nearby, there was a sacred Mahogany Grove. The Dark Forces would not be able to penetrate its protective shelter.

"Here it is!" I shouted to Chris.

"We are rescued!" he declared. "This wall of redskin tree-soldiers will protect and hide us. They will free us from these spells... But, what is this?" Struck with amazement we saw a young tree suddenly split. An axe grew from the wound.

Cracck! The axe began to fell trees furiously and blindly, right and left. They seemed to groan, splitting and falling. From the chopped trunks, tree sap ran like blood.

Oh, horror! It was an environmental slaughter. Someone's hand seemed to direct the edge of the axe. "You couldn't do this if you weren't made from the body of one of us!" groaned the trees, damning their executioner. It was a real "Wood Dead March!"

It was clear that a follower of Ferevoulf made this dangerous wonder and its malevolence was directed against us! In fact, we'd lost any protection we thought the Mahogany Grove could offer. As soon as possible, we had to return to the Center and remain under the protection of its multi-fermion fields. But where are we, anyway? How could we get out of this enchanted thicket?

Natural Tools

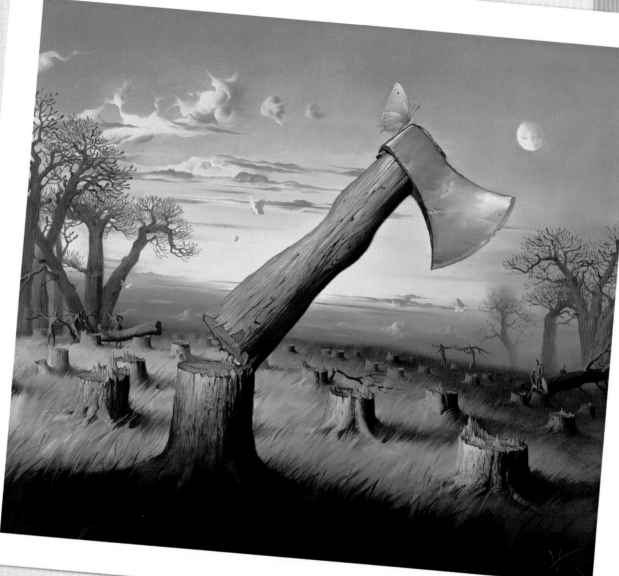

Surfing
the Waves of Memory

Wonder:
Atlas of Wander

August 23. Mahogany Grove had perished, but we wondered whether there were any other forest dwellers who might befriend us. Who would help us find a way out? Did all of the local trees hide villains like Nero?

We peered at the rows of trees, trying to catch a mysterious sign of understanding or sympathy from any of them. Suddenly my attention was drawn to a mighty tree standing alone, some distance from the others. "It resembles the ancient Titan, Atlas," I told Chris, with thoughts of the giant holding up the Sky with its mighty hands-branches.

We approached. The tree seemed to guess our desire. We heard the now-familiar crack of bark and, greatly surprised, saw the trunk opening before us like a book, or rather, like a geographic atlas. One by one on its pages, as if on a display screen, rushed the familiar sea, ships, and finally our Center. With the help of our mic-comps, we quickly determined our position and the route to the Center.

"Now that's something!" I told Chris. "Titan Atlas has turned to the geographical atlas! Now, if only we had a titanic ship."

"Yeah, but not the ship TITANIC!" Chris corrected.

And so we set out on a new path.

46

Menacing Darkness Gathers Overhead

Launching
the Sea-to-Air
Missile

August 24. At last, the forest was behind us. We reached an open mountain country and, believing we were safe from any danger, sat down to rest. But soon, strange clouds resembling gigantic brains started gathering in what had been a completely clear sky. At first, these ominous brain-like spheres were hovering in the air, but then they slowly began to approach us.

One of them let out tongues like suspension cables that were attached to a basket and transformed into something resembling a cloud balloon.
Deep in the sky there arose a shrill whistle that started to increase in volume. After that, we heard the crack of released energy discharges.

A shiver went down our spines as we realized that these clouds were space clots of Dark Matter. There was no doubt of their purpose — to catch us and bring us to Demonopolis, the capital of Ferevoulf's Dark Empire!

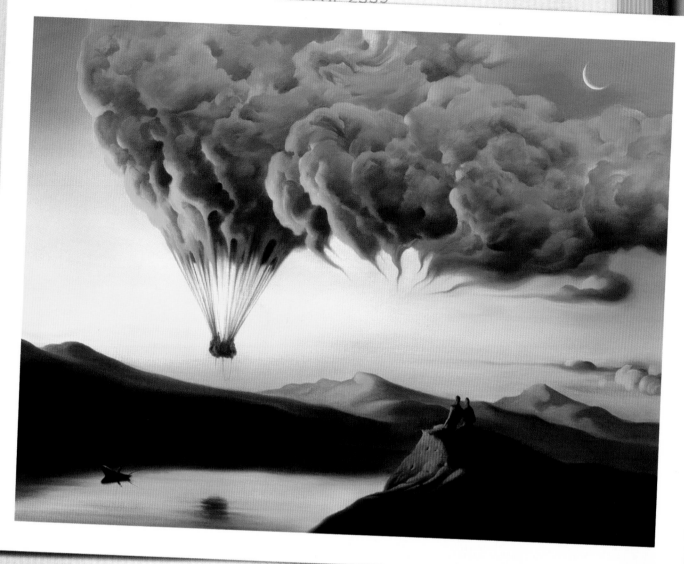

Adam Opens
Parachute Over
the Primeval
Waters

Winged Voyage II

Where to run to hide from them? We were in full view! If only we could turn to stone!

Basketball Fan

"Focus," I said to myself. My glance fell upon a crevice of rock where a bird had arranged its nest, which contained one large egg. The start of a plan ran through my mind. Quite recently we sat hidden, as had Adam and Eve, in the Eden Nut, where nobody could find us. "Eden programs!" I shouted to Chris. He understood me at once and, grabbing his miccomp, started to search for the magic programs for lilliputianization of objects and an algorithm for packing miniaturized objects into spherical bodies. At the same time, I began to feverishly search in my miccomp for the Key of Sealing and Invisibility Program.

In less than a minute, the circles of the program's magic fields were outlined. Entering the program, we were reduced to the right size and placed inside the egg. The nestling looked at us in amazement. Luckily, there was enough free space to accommodate all of us well.

After a while, we heard the sound of huge wings, then felt a push and a sensation of floating. We could see through the translucent shell that a big, white bird had seized us! Seeing the clots of Dark Matter approaching her nest, she had rushed to rescue the nestling, not knowing that we stowaways were lodged in the egg! And here we are in flight — escape was ours!

Safety. We were flying swiftly, shrouded in a translucent sphere. It felt as if we were magnetized to the claws of the mother bird.

"Oh, no. We're discovered again!" exclaimed Chris after a while, pointing downward to an archer aiming a laser arrow at the bird.

"Ferevoulf's Dark Secret Service operates efficiently," I answered sadly. "That must be the well-known Dead Shot."

But we were in luck: the bird carrying us from harm's way was surrounded by a powerful field of bright energy, and no arrow, not even the most sophisticated, was capable of piercing it!

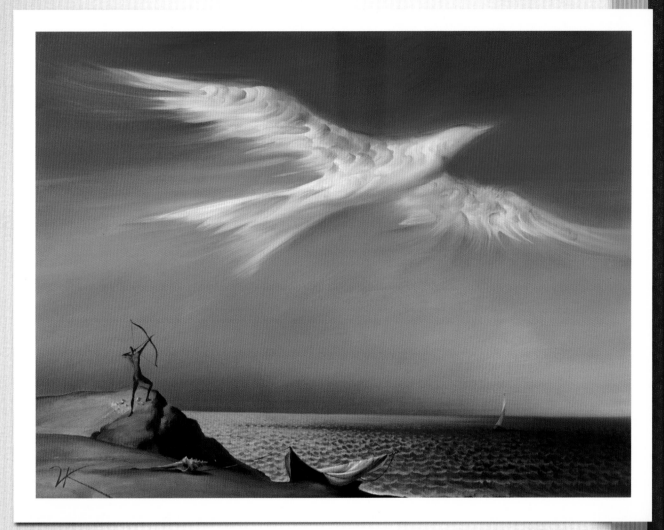

"We are safe and carried aloft by the gigantic white bird, like Sinbad by the bird Rukh!" said Chris, reminded of that ancient story again.

"Yeah, but where?" I asked. "We don't need Sinbad's Diamond Mountains, we need our precious Center!"

Fortunately, our transcom allowed us to establish contact with Big White and we persuaded her to fly to the Center. Once on the ground, we initiated the Unpacking and Returning Program to reverse the lilliputianization process.

"I'm glad we've regained our true appearance," Chris said.

Ah, but if you only knew how cozy we felt sitting in the egg!

Dead Shot is a nickname for Ferevoulf's second assistant, who only ranks below Haron Van Kraaken. A master archer also known as Cosmic Ninja, he performs especially important tasks.

Like ninja, those master spies of ancient Japan, he always operates alone and acts swiftly. He makes frequent poaching raids on the space game living in the star forest reserves of Distant MetaCosm, including Very Deep Fields, where he likes to hunt without permission. For this reason, Dead Shot is particularly hated by the Corporation of Space Hunters.

5. New Adventures on Zeno Island

Preparing to Depart

August 25. The Supervisor met us in his office and praised us for showing such resourcefulness during our recent escape from the Forces of Darkness.

"It was the first test of your abilities. The next stage of your practical work involves a trip to Bioassemblage Island where prototypes of living beings are built," he declared.

We would have seven days to explore the island on our own while our old, tested ARK was being prepared for departure. We decided to start with a short walk along the deserted sandy beach of Zeno Island.

Precious Pearl with Rays Outstretched

The first surprise was our encounter with a gigantic pearl. The Custodians of the Pearl had just opened the folds of the great seashell as we approached it. They told us that Precious Pearl (its official name) was a main source of bright energy, capable of neutralizing the harmful energy that emanates from Dark Matter. This destructive substance is often used by Ferevoulf's forces in their evil operations.

Barbie
Clamdestine
Beauty

The Custodians cultivated this gem at the bottom of the sea for a very long time. Lying on the ocean floor, Pearl absorbed and accumulated the rays of bright energy dispersed in the ocean depths as they traveled from the double green stars of the Bethlehem Constellation.

Soon, Pearl will be sent to the Center, and its rays will help treat beings suffering from the effects of Dark Matter's radiation of harmful energy. The Custodians told us that in addition to Precious Pearl, they cultivate small, technical pearls at the Center. These are used in devices like our Neutralizers of Dark Energy.

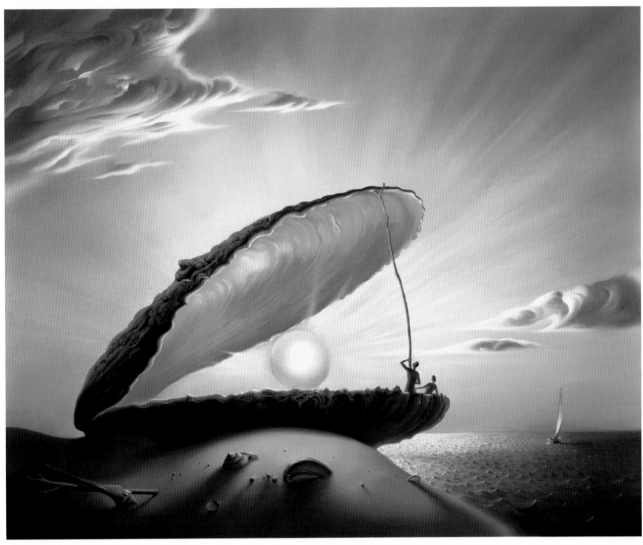

Pearl Harvest

Descent of Shadow Down to El Zagrado

August 26. Again, we were attracted by the brilliant blue sea and set out to continue to explore the beach, walking almost as far as Achilles Cape. On the way, Chris took a photo of me going down some stairs. Looking at the picture later, I realized I could only see a silhouette of myself.

Puzzled, at first I thought that at the moment the photo was taken, I had unexpectedly shifted into Four-Dimensional Space. In school, we learned that a person going into the Fourth Dimension (such cases are extremely rare) would form a silhouette that looked like a hole in our space. My guess turned out to be wrong. We later learned that this wonder had been made by the bright radiation that emanates from a powerful source like the Precious Pearl, which we had visited the day before. Center experts explained that a human body under Pearl's influence could become clarified and would be protected against any illness for a long time.

Signaling Sea Dangers

Escaping Specter Spectacles

August 28. Another day at the shoreline... "Look, someone has forgotten his dark spectacles!" *Chris shouted. He picked them up from the sand and stretched to hand them to me. I shuddered. Living eyes were looking at me from the lenses. Their stare was haunting and cold, and seemed strangely familiar to me.*

"What's the matter with you?" *Chris asked.*

"I can't get the eyes to stop looking at me," *I said. No matter how I turned the spectacles, the eyes followed me persistently.*

"Jason, what eyes are you talking about? That's just an old pair of sunglasses someone forgot on the beach."

"Don't you see them?"

I know he answered me but I didn't hear what he was saying. I was too busy thinking about how those eyes reminded me of the Tower of the World Spider. Suddenly, in the depths of the spectacle eyes, multi-colored loops and spirals flared up in a geometric frenzy. Like a magnet, these spirals were attracting all of my thoughts and feelings, while an irresistible force was insisting that I put on these glasses!

The duel seemed to last an eternity. I resisted with all my strength and don't know what would have happened if it hadn't been for Chris. Seeing that something was terribly wrong, he snatched the glasses out of my hands, and threw them as far into the sea as his arm would allow.

"Now then, are you a bit better?" *I heard him say as I came back to being myself again. I was too shaken to talk and could only muster an emphatic nod.*

"We're going back to the Center," *he ordered,* "to ask what they know about this."

On the way back, I remembered that precisely the same piercing, eerie look had met my eyes in the Tower of the World Spider. I asked myself again and again: Where did it come from and why did it seem to only pursue me?

Microsaw™
Octopus Software

Octopus City Approaching

We returned to the Center and addressed our Supervisor. To answer our questions, he immersed in deep meditation, then approached the multiple displays and called the Department of Classified Information Storage.

The enormous Space Survey Screen lit up almost immediately. Utterly shaken, we saw the outlines of a gargantuan octopus hovering in a cloud of Dark Matter. Instead of suckers, the horrid trunk and the tentacles of the monster squid were dotted with phosphorescent lights that were clustered in ways that sometimes resembled the strange palaces of Ferevoulf's Imperial Night Court. When my eyes met the piercing eyes of Octopus, they were strikingly familiar.

"You were haunted by the eyes of the biocosmic octopus robot. Its body contains Demonopolis, Ferevoulf's capital city," explained the Supervisor. "But it looks very strange indeed! The Dark Cloud usually floats somewhere near the constellation of Fiery Scorpion but now it is approaching Earth. This is most unusual and troubling.

"The incident with those forgotten dark glasses is now completely clear to me," continued our guru. "Had you put them on, you would have lost the ability to sympathize with people and to do good. Shortly, you would have lost all human feeling. The Dark Energy of Evil would have been instilled into your heart. But, I wonder why Ferevoulf has such an interest in you."

We couldn't find any reasonable explanation but one thing was clear: I had attracted the Forces of Evil in a way that Chris and others did not. The Supervisor

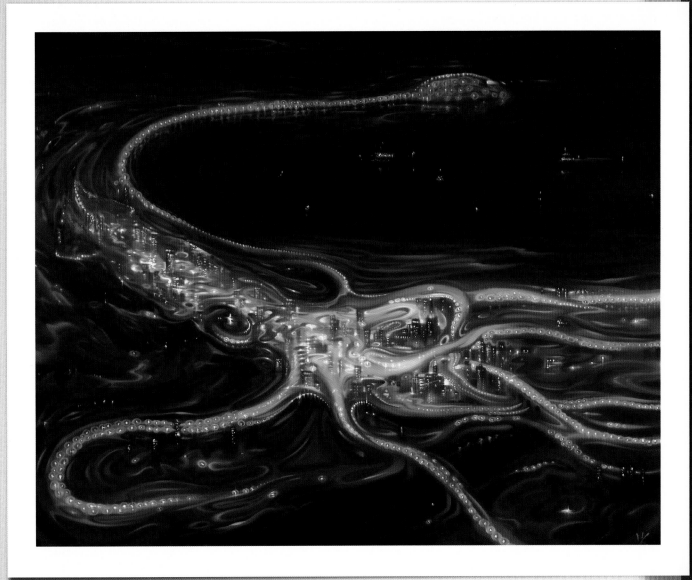

grew absorbed in reviewing the records of other similar encounters. After a couple of tedious hours he rose from his desk so abruptly that it startled us.

"Now, I see the connection to you!" he exclaimed. "You represent a major threat to the Prince of Darkness."

I was astonished. "Me?" I asked.

"What ever did Jason to Ferevoulf?" asked Chris, equally astounded by the Supervisor's proclamation.

Seal of Salomon

Sibyl Book

Eagle of Delphi's Oracle

"It's not what you've done, but who you are," said the Supervisor. "I've just consulted the World Family Tree and the data stored there says that Jason is descended from the ancient Etruscan people, a civilization that the Roman Empire considered very experienced in magic and divination. In the centuries following the rise of Rome, some of the Etruscan clans were integrated into Roman society, others turned Barbarian, but one clan relocated to a part of the Roman Empire that later became known as England, a part of Great Britain. Centuries after that, they left their homeland to colonize newfound North America. When the United States of America gained her independence from the British, these descendents of Etruria were skillful mechanics and gunsmiths. They became the Connecticut Yankee that the Early American writer Mark Twain wrote about."

"Is that why we saw Nero in the forest?" asked Chris. "Because of this Etruscan connection to Jason?"

"Indeed it is," said the Supervisor. "Ferevoulf used the Roman figure of Nero to lure you into a trap. He hoped to arise in you the call of the blood, a desire to do something so ingrained that you would not be able to resist."

"Something like stay and fight the Dark Forces," I said.

"Very much so," confirmed the Supervisor. "And you should know what was written in the Book of Sibyl by ancient Rome's great prophet and priestess."

I was not entirely sure that I wanted to know more or could even absorb it. But the Supervisor continued, "the book contains a prophecy that one of these descendants of Etruria, Jason Astrorum Temporumque Sapiens, will put an end to the Forces of Darkness that breed the Evil on Earth and in the Star World. All evidence says this descendant is you, Jason!" concluded the Supervisor.

Our attention was drawn again by the display screen, which was filled with the Dark Cloud and the Octopus City that hovered inside it. No ray of sunlight had ever penetrated into this black-veiled world where eternal night reigns. Only false lights glitter there, where sinful, black ideas rush across the gloomy sky — ideas designed to enslave and distort the entire Universe.

Tentacle N3, block N5, Octopus Cave City, Fiery Scorpion Constellation, 00666

Babel Family Tree

Shoot
of Mankind Tree

August 29. It took me a while to digest all that the Supervisor told us. After the initial shock wore off, I found that curiosity got the better of me. "Yesterday," I told the Supervisor, "you mentioned the World Family Tree. What is it? We haven't seen it yet."

Since the ARK was ready ahead of schedule, he had us brought to it immediately so we could set sail for the site of the World Family Tree. Standing at the foot of the Tree, we listened to the explanation offered by its Guardian. "The World Family Tree stores all data on all people that have ever lived on Earth." "All people?" asked Chris. "That's an astronomical amount of data!"

"All people," replied the Guardian, "from the creation of the world until now. Data is also recorded on their relationships with each other. Information about ancient peoples, for example Cro-Magnon race, is placed on the files stored in the roots of the Tree, while data on their descendants is stored in the trunk. The more recent a particular race is, the higher up the tree toward new growth they appear. Construction of the Tree isn't completed, of course. Each people, from large groups like the Chinese to a tiny disappearing tribe of Amazonia, will eventually have its own branch," he concluded proudly.

Then, we set out to see the tree-tower. We walked around the long underground root-tunnels, clambered with great pleasure through the branches, and were lifted in a basket to the treetop that disappeared into the clouds.

Construction was in full swing. We visited the Depository of the Pioneers of America, the Depository of Information about the Settling of Easter Island, and several other interesting places. Finally, the Guardian led us to the Center of Reunification of Peoples into United Mankind, also known as the AntiBabel Center. The name seemed a bit strange to us. However, the Guardian reminded us of the Bible passage:

> Once there were no separate individual peoples, only one united mankind. But people proudly decided to build a tower that reached to the skies. Then the Lord divided them into the separate tribes speaking in different languages so that they could not speak with each other and finish the Tower.

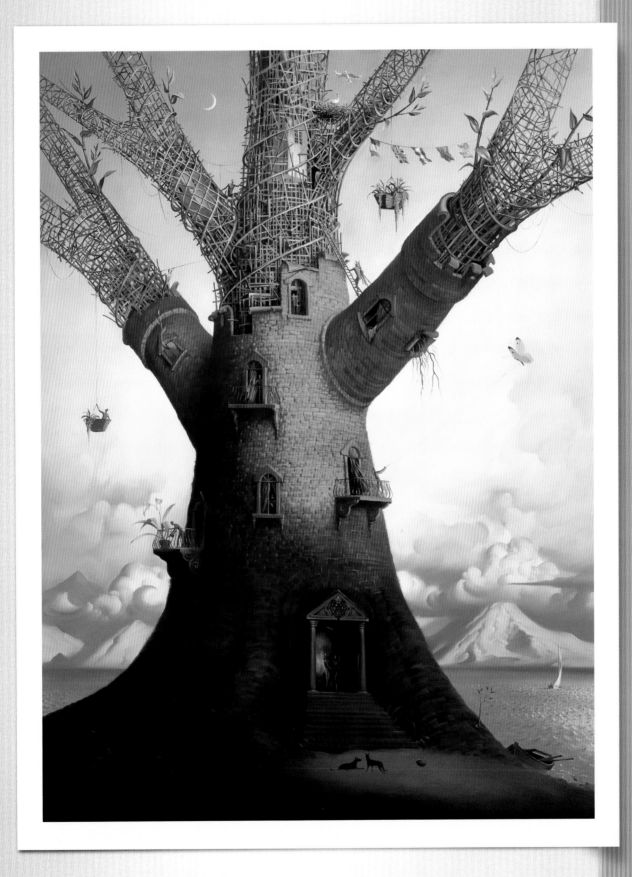

"Now it's clear," I said. "Those who want to unite all peoples together again, who want to turn back Time, must do an AntiBabel deed. Hence, the name of your Center!"

"Correct," said the Guardian. "By the way, another remarkable Babel structure exists farther down the shore — the Horn of Babel."

Well, your genealogic Tree deserves the name of Babel more than an unknown horn, I thought. But I kept this thought to myself as it had proved important to keep from forming opinions before seeing things in this strange land. Meanwhile, Chris was quite willing to challenge the Guardian with questions. We hoped that we would succeed in persuading him to show us our personal files (although it's strictly forbidden). He declined politely but his words intrigued us, so we decided to use the time that remained before departure to get closely acquainted with this, so to say, New Babylonia.

Along my Family
Lines

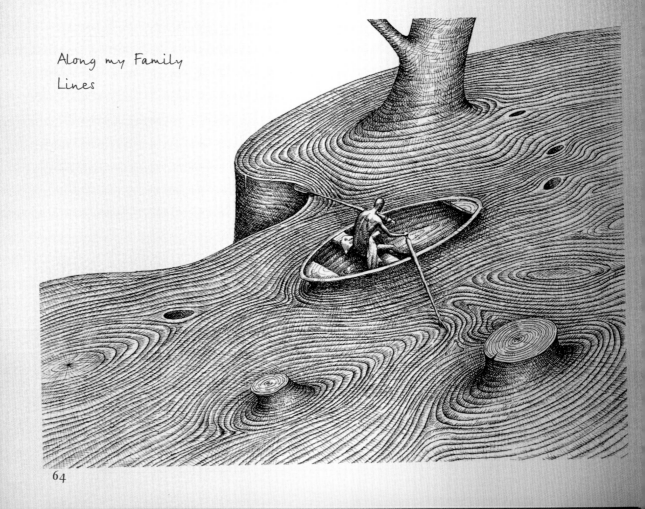

Cultivating Dwellings at the Babel Horn

August 30. We traveled on in search of answers.

"But why is the Horn called Babel?" wondered Chris as we walked toward it. "We've already heard about the Tower of Babel... Hmm, perhaps, the structure is really similar to a tower, only bent and thrown to the ground." He squinted, looking skyward.

"Of course," I realized, "It was bent and overturned, sent to the ground by God's anger! Once we pass through that next cluster of trees, we should be able to see it."

"Look," said Chris, "it hasn't really been completed — like the Babel Tower itself."

We asked the Guardian of the Horn for any explanation he could offer.

"Our Babel Horn of Plenty operates now as a factory for the cultivation of bio-houses," he said. "Like mushrooms in underground tunnels, these small houses are breeding in the Horn according to the Cornu Domus Method. Once bred, they are then scattered along the coast. The population of Zeno grows constantly, needing ever more dwellings."

"But all of the houses seem completely identical," I said. "That's rather dull."

"Only in outward appearance!" objected the Guardian, "The interior of each house — walls, furnishings, decor — is absolutely unique and amazing by the biodiversity of design and decoration.

We were quite willing to go inside a house to have a look, but the ARK's captain interrupted. He'd gotten an urgent message via a special communication channel and it could not wait.

Babel's Bounty

66

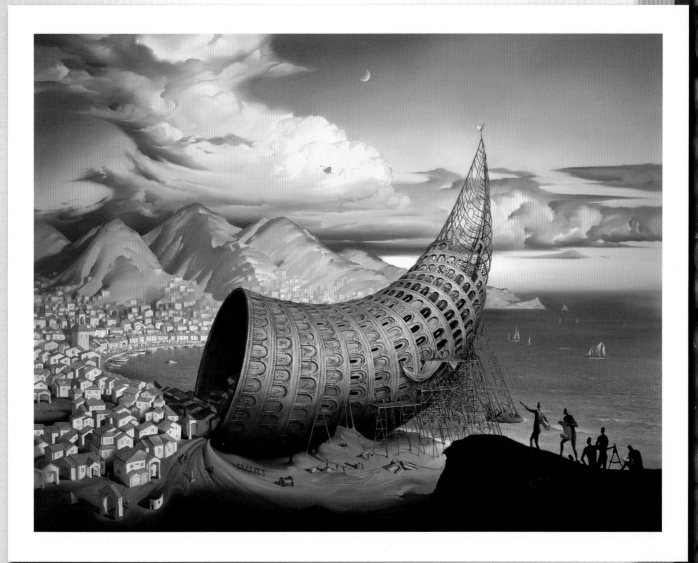

The One
Who Flies
Over the
African Horn

6. Trip to Bioassemblage Island

Dark Tunnels at the Edge of the Earth

August 31 – September 1. The Cap hurried us. To get to Bioassem Island, the ship had to pass along the Edge of the Earth. It was a dangerous enterprise, but our captain was not easily frightened. An "old salt," he had passed along the Edge of the Earth 28 times. In our conversation with the Guardian of the World Family Tree, we learned that Cap was a direct descendant of the legendary Captain Nemo, commander of the submarine NAUTILUS.

According to Cap, an unusually early storm was approaching that would start the year's season of sea storms, so sailing immediately was imperative for our successful navigation along the Edge.

ARK OF JOY *sailed across the waters of El Zagrado with grace. Standing on the ship's deck we were watching the open view, amazed by its grandeur. Our Guardian World stood on a distant mountaintop, anchored by a Herculean pillar whose base was lost somewhere far below in a heavy fog. A gull's cry fell silently across the void of this watery canyon. It seemed unreal, as if it came from another world. Cap described how the seawaters would pitch and the winds howl through this chasm during a storm. With images from Dante's Hell, we were relieved that there were no such storms in sight today.*

"Well, it's not such an empty place here," said Cap, listening to our talk, "though the depth of the chasm reaches nearly to the center of the World. As children, did you dream of reaching the edge of the earth? Well, there it is, right before you! Rather frightful, isn't it?"

Indeed we were frightened, but curiosity overcame fear. Watching the ARK *pass perilously close to the black chasm, we were all eyes. This exposed fissure of the*

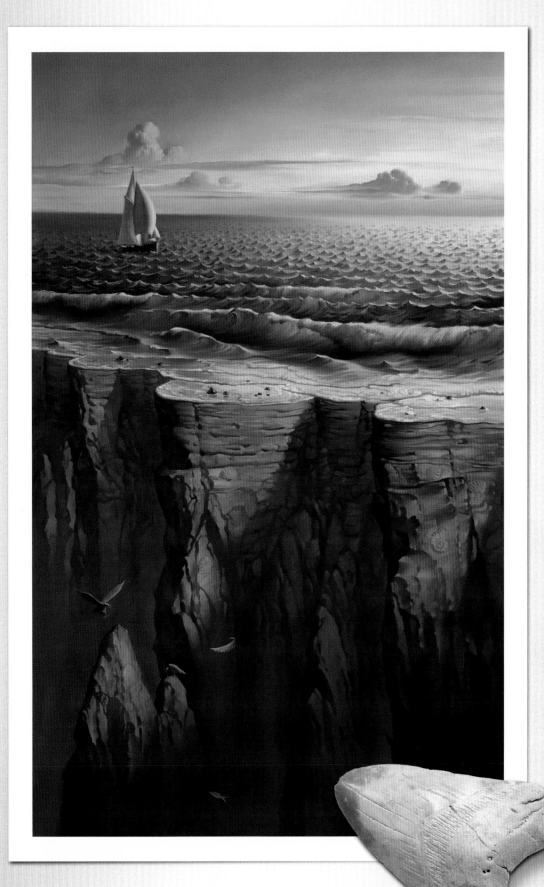

Megatooth of Megalodon, Lord of Sharks

Guardian World resembled the Grand Canyon, only it was much, much deeper and the sea ran to its edge. Clearly, the laws of the natural world were suspended here.

"If it is the Edge of the Earth, then there is only a way there, in nonexistence, a way back does not exist. So how can the Forces of Evil penetrate here, to us?" I asked Cap.

His words returned us to reality. "The protective field of G-World mainly covers its surface and, to a lesser extent, the foundation — the rocks of the Pillar. Recently, the agents of Ferevoulf's Dark Empire have learned to overcome the protective field and covertly penetrate it to gain access to our land. They drill tunnels in the rocks at the Edge of the Earth, and make their way through them to El Zagrado, then they move farther to Bioassemblage and other islands. Ferevoulf's first assistant, Haron Van Kraaken, sets his elaborate traps there and introduces elements of chaos into the work of our biorobots.

"But that's not all! In the secret laboratories of Demonopolis, Van Kraaken's scientists developed extremely damaging twin viruses — Tutankha and Nebucha," continued the captain. "They put intelligent beings, including biorobots, into a zombied state by sending the encoded double spirals of Evil into their brains. As a result, infected people and androids fall into a hypnotic trance and their actions become unpredictable. The spirals of Evil also inspire them with a seemingly random passion to render destruction and create awful crimes."

"Random?" asked Chris. "Or do they only look random because these acts appear whenever the spirals turn toward the correct brain receptors?"

"I see ChroMec still does a good job teaching basic neurology," said Cap. "Yes, to be precise, the acts that appear random are not so at all, but are triggered by the shape that Evil takes inside the brain. Since each person has a slightly different brain chemistry and the lobes of the brain, while regular in shape, can be different in size, even if two people are infected with identical spirals at the same moment, they will respond differently."

"Diabolical," I said. "This randomness must make it all the more difficult to recognize and neutralize."

"Quite so," said Cap. "Van Kraaken's agents are tasked to sow chaos everywhere and they are quite good at what they do!"

"So they are Ferevoulf's messengers, those that we cannot perceive but who nevertheless exist?" I asked.

"That is our theory, and our only recourse is to fight them to the death," answered the captain.

As we tacked into the wind, his hand pointed out the enemy's places of possible penetration on a map that hung in a cabin below decks. "Maybe we'll have to send our Patrol Fish to these aquatic regions," he said.

"Patrol Fish?" asked Chris.

"You'll see them when we arrive at Bioassemblage Island."

Just half an hour's journey to the island remained as the worst apprehensions of the captain began to come true. A storm broke over the sea, threatening to plunge our ship into the terrible abyss we had nearly navigated past.

War of Microworlds.
Episode 3: Invasion of Nomad Viruses

Saved by the Candle

September 3. We battled the storm on El Zagrado Sea for what seemed like an eternity. No natural phenomenon caused it; Haron Van Kraaken commanded his Forces of Evil to transform into a terrible storm designed to sink our ship. The ARK was a strongly built vessel that had weathered many heavy storms, but the assault was formidable.

Using powerful emitters of Dark Energy, our enemies disabled all of the ARK's astronavigation equipment, so that at any moment the ship could plunge over the edge into the roaring abyss. Despite all of the efforts of the captain, the ARK moved closer and closer to the edge of the precipice.

"Here they are," exclaimed Cap, pointing to the control displays' flickering screens. "The Forces of Darkness come on the astronavigation screens in the form of these pictures." I peered into the monitor. Multi-colored spirals, zigzags, and kaleidoscopic patterns were rushing across it, each one swiftly replacing another. I closed my eyes to clear my vision but continued to see the patterns, as if I were under hypnosis. Horror-stricken, I felt I was being sucked into the patterns. It was like drowning in quicksand. I opened my eyes and the patterns disappeared from the screen, which flashed a pair of empty, lifeless eyes behind a mask.

I wasn't able to move and almost lost consciousness listening to the mutter of a strange language coming from the control panel. Jutankha-Nebucha, Nebucha-Jutankha, Jutankha-Nebucha, Nebucha-Jutankha hammered in my head. Then, I felt myself falling into the bottomless well again. Looking up, I saw a masked figure looming above me at the top of the well. "I've remembered everything," it hissed before vanishing.

Dance
of Death

This mask is Nero! Again, he tries to pull me — together with our entire ship — into his death well, Nada.

I remembered the Supervisor's warnings and rallied all of my strength to press the button on the Neutralizer of Dark Energy. Back on the ARK, I shook away the delusion.

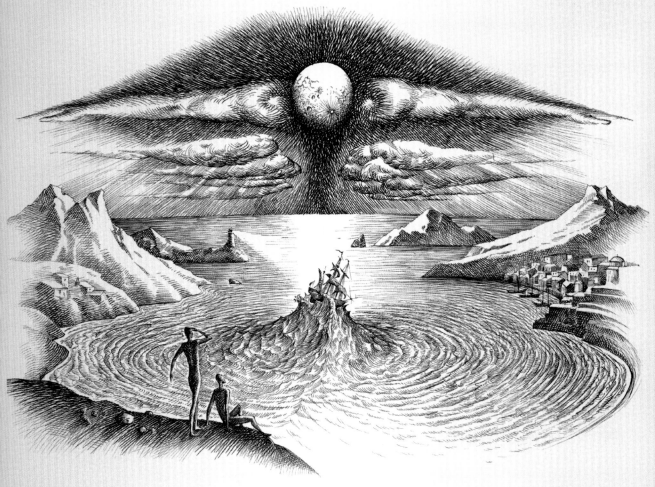

The Ark in the Vortex of Dark Energy

But not only was our equipment attacked: sea monsters had been sent by Van Kraaken to seize the boards of our ship with their piranha-like teeth. Together with the ship's crew, we opened fire from every kind of weapon available. Meanwhile, a greater danger was emerging several miles away where the sea suddenly swelled and produced a greenish tornado. In an instant, this waterspout turned into a giant spectral figure that swiftly approached the ship.

"It's Van Kraaken himself," exclaimed Cap. "Impossible! I've never met him in these waters. Prepare the lifeboat," he ordered.

"Leave the ARK behind?" I asked. "Cap, she'll be devoured."

"When Van Kraaken appears whirling his dance of death it's only possible to manage him with an AntiVortex Gun, but we don't have one. Get in the lifeboat!" ordered Cap, pushing Chris and me inside it. "You both steer clear of the edge and let me worry about ARK OF JOY. Take this quadrocom and send a coded distress signal to the Center."

As soon as the lifeboat was in the water, we started the engine. In a moment, we had disappeared under a spray of crashing waves. At our backs, the whirling Van Kraaken picked up the ARK and carried it away to the Edge of the Earth. We were out of visual range too soon to see the ship's final fate. We were alive, but our situation was desperate. The sea roared like the Beast of the Abyss, and wild, dancing waves threatened to capsize and sink our fragile boat as we rocketed forward through the rough surf.

Time passed and there was no sign of a response from the Center. Then, in the gathering darkness, a rocky coast appeared. Upon it, a candle of salvation was protected from the storm by strong hands that appeared around its flame. The candle's bright glow lit up both our ship and the turbulent sea around our small craft. We were saved by the hands of the Supervisor, who arranged our rescue in response to the distress call that now seemed so long ago. The candle's hyperion field was directed toward our boat from the Center's powerful generator. Bathed in its glow, we were illuminated in the field's protective shielding as the dangerous waters continued to swell around our boat.

Beasts of the Abyss

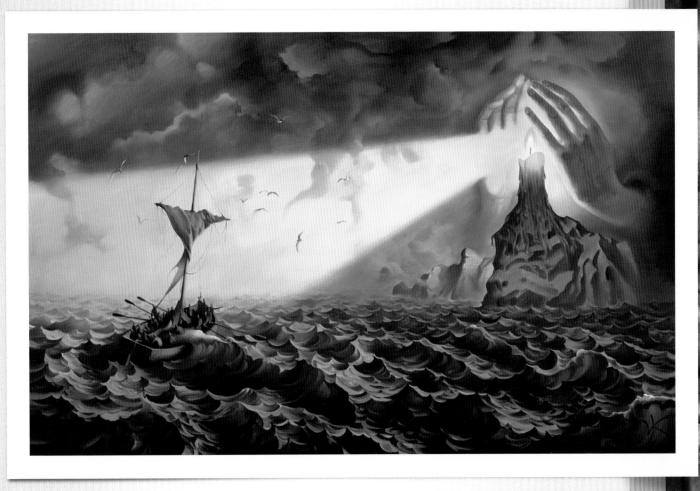

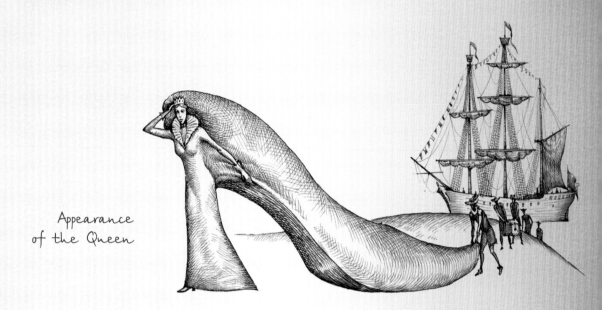

Appearance
of the Queen

Dancing on the Waves

September 4. Fortunately, it did not take long for us to be picked up by a small ship. Rather strange and ridiculous, the outlines of the Princess Cinderella *looked like a woman's shoe. As we learned later, the ship was built for the inhabitants of G-World to use for cruise vacations. Designed by the famous shipbuilder Joachino Yamamoto, the shipbuilder's imagination was said to have been inspired by the ancient Cinderella story (a magical shoe lost at a formal ball is the only clue to Cinderella's identity, hers is the only foot in the kingdom that the shoe fits, so she and the prince live happily ever after with the image of the shoe emblazoned on their coat of arms, etc.).*

The captain of the Princess *begrudgingly changed course to bring us to Bioassem Island. His itinerary did not include time to veer so far off course or to stop at such an industrialized port.*

Exploring the ship, we were absolutely fascinated by the Princess's *method of propulsion — the craft seemed to dance on the waves. After our anxious times aboard the small lifeboat, we were quite willing to amuse ourselves by investigating below decks on this luxury ship. To our amazement, we found dancing and concert halls populated all of the decks of this strange vessel, upon which several lavish Cinderella balls apparently could be found at all times.*

Although our captain regretted the forced course change, he allowed us unrestricted access to the ship's pleasures.

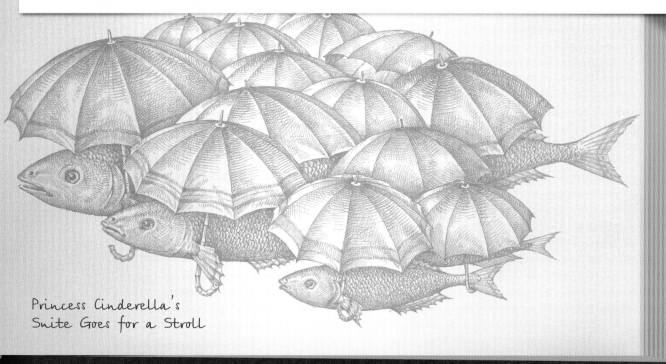

Princess Cinderella's
Suite Goes for a Stroll

Ogygian Puzzle Profile

September 6. After indulging in Princess Cinderella's *diversions until we grew exhausted, Chris and I rested in our cabin.*

"You know," he said, "the courage and persistence of Cap reminds me of Ulysses. I think that despite the loss of the Ark, *that wasn't his last encounter with Haron Van Kraaken."*

"Are you so certain Ark *was lost?" I asked.*

"No. Strange things happen in G-World and I suppose she could have been spared in some way we would neither expect nor imagine. Besides, do you remember the ship in the ancient story of the Argonauts? Maybe, like the Argonauts' ship, Ark *was a smart ship, a living being to a certain extent, capable of struggling against all kinds of calamities."*

"As for Cap, don't forget that his ancestor, Captain Nemo, became famous fighting the huge octopus that seized his submarine Nautilus *with its horrid tentacles."*

"I don't know much about Captain Nemo," said Chris, "but I keep thinking about Ulysses. He had time to rest up from his trials on the way home. After his ship was wrecked, he lived with the beautiful nymph Calypso for years in the paradise isle Ogygia."

"Quite a reward for his adventures," I said. "Imagine being shipwrecked like that." Right then and there we turned on the chronoscope installed in our cabin and found an image of Ulysses sailing away from Calypso toward new adventures.

"Look, Chris," I said, sketching an outline on the scope, "what a wonder! Do you see a profile of the nymph?"

At first, he was puzzled. "You're right," he confirmed, still squinting. "And what does the word Zeno — as in Zeno Island — mean, anyway?"

"Its roots are ancient," I said, "Greek, maybe."

"Another antique name, like Calypso or Nero? Let's query the chronoscope on that, too." Chris spun the dials. "Hmm, yes, Greek. Says he was a philosopher fond of paradoxes. He asserted that a flying arrow didn't move at all."

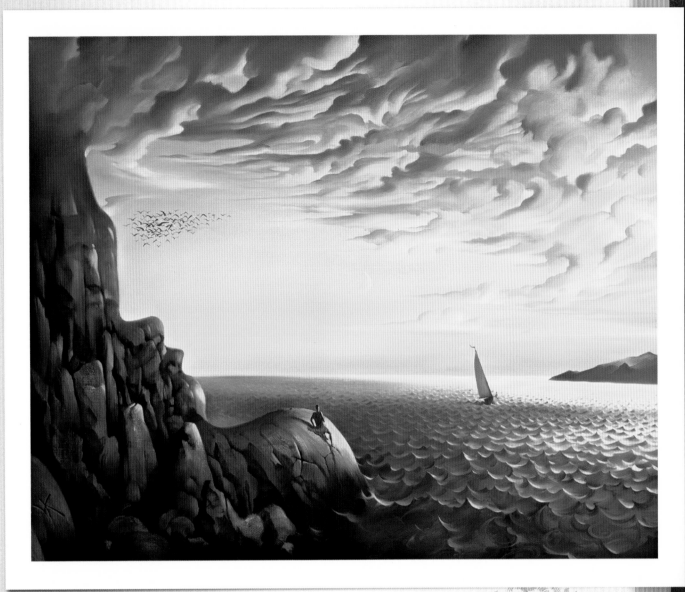

"Do you think he meant our Arrow of Time? Then, no wonder Zeno Island has been named for him."

"And I won't be surprised if we find his profile cut somewhere into Zeno's cliffs," said Chris.

Remember your Home

Golems!

Reviving the Sea Watch

September 7. As our small ship approached the harbor surrounding Bioassem Island, we saw a shipyard and the gigantic outline of a fish being shot with metallic glitter.

"That," said CINDERELLA'S captain, pointing to the biorobot, "is our hope – a Patrol Fish built at the Poseidon Shipyard. I just received a message the other day that the Patrol Fish returned from its last raid all covered with wounds received in a battle with unknown underwater monsters. Probably, the same Sea Golems sent by Van Kraaken that nearly ate you two."

"It looks like the Patrol Fish took quite a beating," said Chris as we surveyed the damage.

"The release of Sea Golems was unanticipated," said the captain. "According to intelligence information, these evil creatures were hiding in sea caves located near the island. Our Patrol Fish was not quite ready to fight such dangerous beasts. But, see the sides of the fish are being sheathed with scaly armor to protect it? That armor," continued the captain, "is similar to the special schintrones – scales – that protect our spacecrafts from the dangers of outer space. It will be too tough for any of Van Kraaken's infernal beasts."

The captain also told to us about the development of a special weapon – the AntiVortex Gun that was being designed specifically for use against Van Kraaken. If this weapon had been aboard the ARK, Van Kraaken may have been defeated already. Impressed by the tragic state of the Patrol Fish, for the first time in my life, I wrote a poem.

Some day, I may even dare to show it to Chris, but he'll probably tell me I've been thinking about Ulysses too much and am writing under the influence of Homer.

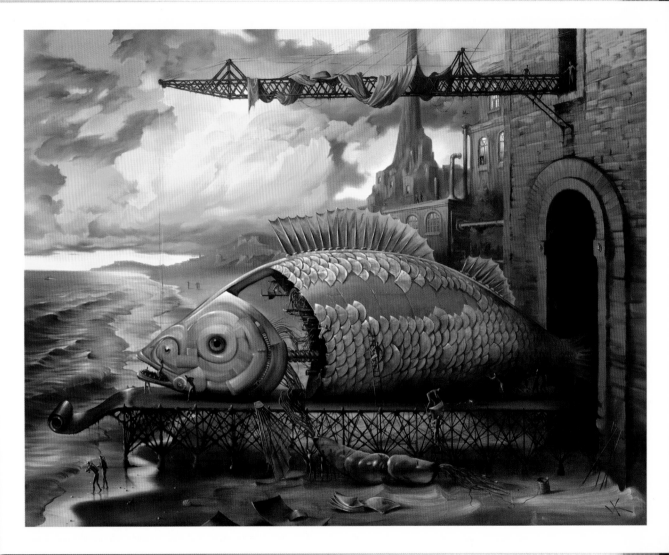

At the time when it disappears
 from eyes and starts to go,
Led by the finest mechanism of the computer brain,
At that time we all will hear the voice of the Fish
Overcoming the dumbness of a spell,
Coming to us from the immense space
And opening the secrets of the Ocean to us.

Leon and the Planet Devourer's Foresight

September 9. Bioassem Island was an engineering complex like we could never have dreamed. In the workshops of its Practical Cosmos Laboratory we watched the progress of the creation of two new biorobots: Chameleon and Dragon Fly. Cloned into thousands of copies, this pair of cosmic pioneers will play a crucial role in developing the Galactic Frontier. Here, the wild planets of the remote star worlds are unfit for life at this time. Some of these planets have no atmosphere at all. The atmosphere of others is poisonous or radioactive.

According to the Chief Designer accompanying us during our visit, hundreds of Chameleons would be sent to such planets to perform the transmutation of harmful radiological surface contamination and to neutralize poisonous substances. These toxins would be replaced with a new atmosphere compatible with human life.

"So, these creatures will work as biofactories?" Chris inquired. "I've never heard of anything like it." In school, Chris was always immersed in planetology and knew the histories of dozens of planets settled in our galaxy.

"This is a completely new technology," said the Designer. "The main point here is a metaplastic transformation of the substances composing the surface of a planet, its earth, so to say. Not without reason," he continued, "it was decided to return to this chameleon its ancient name, HAMAI LEON, the Earthen Lion. At first it will devour the earth of a new planet. Thus, its skin will become black in color. Next, digesting the absorbed matter, biorobot will, as all chameleons do, change its color from black to red, green, and at last blue — the color of the planet's future atmosphere. And, finally, the mouth of this man-made Saurian will belch out a clot of air, which the future inhabitants of the planet will breathe."

"Can it do anything else?" Chris asked sarcastically.

"Indeed," said the Designer. "Hamai Leon will be able to see the Past with one of his eyes and the Future with the other eye. Thus, he will be our Watchman who reveals the Forces of Darkness' hostile plots in advance."

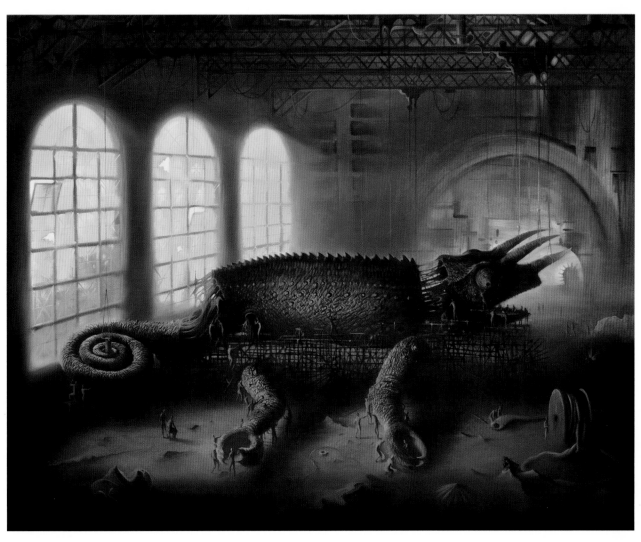

Life-Giving Dragon

September 11. We learned that after a planet is shrouded with the blue haze of its new atmosphere, the Dragon Fly would be used. "Hovering above the planet," the Designer told us as we entered another workshop, "they will populate its surface with multiple micro-organisms and plants, continuously cloning them from the prototypes stored in the database that resides in the Dragon Fly abdomen. At first they will sow the quiet water surfaces — lakes, backwaters of rivers, sea gulfs — using their faceted eyes that are capable of seeing a thousand things in all directions, to skillfully select those places most favorable for life."

"Then I'd propose calling it Dragon Life instead of Dragon Fly," quipped Chris.

"Your joke makes more sense than you probably realize," our guide said, smiling. "In antiquity, the dragon was worshipped as the God of Fertility. But, to continue, terrestrial plants will also be seeded. The crown of Operation Dragon Fly is to populate the planet with a variety of beasts from the animal kingdom. After that, the re-formed planet will be ready for colonists from Earth and other inhabited worlds."

We knew from our time at the Center that the first planet chosen for Operations Hamai Leon and Dragon Fly was in a galaxy near Kepler's Unusual Supernova Type H, nicknamed KUSH, in the constellation Ophiuchus.

Dragon Fly's
Tactical Exercises

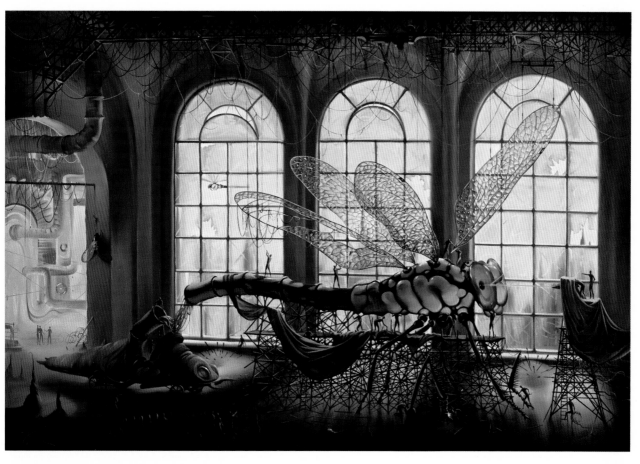

7. Space Mission

The Challenge

September 20. After returning to Philopolis we were immediately called in to see the Supervisor, who promptly informed us that the High Council of Chronophylaxes had accepted us both as First Category Chronomechanics. We were in ecstasy!

"Well, given that we consider your practical work very successful," he said solemnly, "this is a natural progression of your studies. The Center planned to put you to a serious test during the last voyage of the Ark in El Zagrado," continued the Supervisor, "but events went out of our control and exposed you to real and very serious dangers. Throughout it all, you both proved quite resourceful. Besides, now that you have used the Neutralizer of Dark Energy under real circumstances twice, you are seasoned soldiers of MetaCosmion."

But there was much more. The Council wanted us to serve as members of the basic staff. We would head out with the first intergalactic mission.

"We live in uneasy times," the Supervisor lamented. "The struggle between the Forces of Light and Forces of Darkness grows increasingly aggravated. To advance this competition for vital space in MetaCosmion, the Center has developed a sophisticated plan to use biorobots on the planets located in Near Space and then in Outer Space. Capable of cloning, they will support humankind in expanding the Space Frontier and fighting against the Dark Forces as they emerge in any form, whether physical or virtual. As the Dark Forces inundate the World with their torrid flood of Evil, we must stem the tide. Our place in history is not unlike that of the biblical hero Noah, who saved many living beings from the Great Deluge."

"Supervisor," said Chris, "tell us more about this mission."

"Its purpose is to initiate the settling of biorobots on the first 100 planets in the nearest galaxy. You already know your future assistants, space pioneers Hamai Leon and Dragon Fly. On a secret range of Bioassemblage Island, our scientists are nearing completion of another biorobot – the transport spacecraft STAR-BLUE BUTTERFLY. With the use of the magic programs of lilliputianization and packing, STAR-BLUE is quite capable of carrying colossi-class biorobots and the entire crew. This new spaceship will be called NEWARK, to honor both the name of Noah's ship and commemorate the valiant efforts of our own ARK OF JOY."

Noah's Cosmic Ark

13 September, 2004. Scientists plan to create the Cosmic Ark – a "lunar sanctuary" to preserve Earth's whole record of life in case the planet is destroyed. It would be a compact archive of DNA that could be "downloaded" when necessary. It would act as a miniature Noah's Ark for repopulating the Earth in the event of a global cataclysm. Scientists estimate that a kilometer-sized asteroid could cause planetwide devastation.

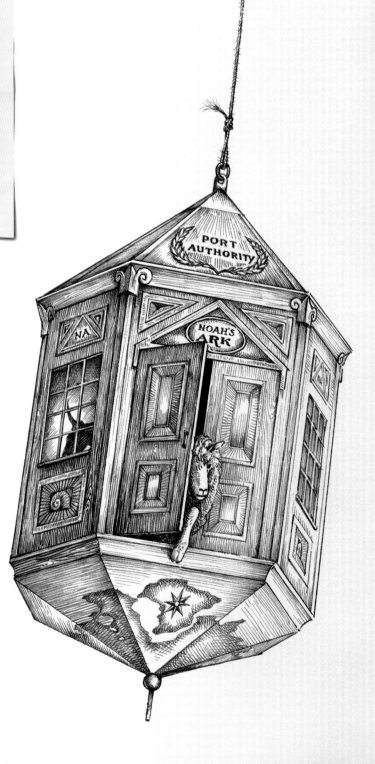

Entering the Superpeople Hatching Plant

September 24. Today we returned to the Laboratory of Practical Cosmos where we'll train to fight Ferevoulf's Golems. Our new instructor, Director of the Lab's Training Center, met us at the entrance and, with a wide sweep of his arm, invited us to look at a nearby computer.

"You'll live here," he said, tracing the geographic outline on the screen with a small stylus he'd retrieved from his pocket, "for some time. This man-made peninsula is cut off from the rest of Bioassem Island. Its outline resembles a huge leaf — no mere coincidence. Our bioconstructors modeled this terrain on a rare plant leaf discovered in a hidden corner of the ancient planet, Amerazonia. It has the ability to survive in the most hostile and rapidly changing of environments. The thorns here," he tapped the stylus against some dots on the screen, "play a key role. Through these projections, cosmic energy is absorbed and discharged to repel enemy attacks. This intelligent leaf settlement is named Cordatum-3000."

"Cordatum is ancient Latin," said Chris.

"Yes," said the instructor. "It means in the form of a heart and is similar to an old alchemical sign for Sacred Heart because the leaf performs something of an alchemical transformation to inhabitants. The harsh conditions created here greatly expand the intellectual and physical capabilities of ordinary people, increasing energy reserves and potential, improving genetic structure, etc. All this turns people into Superpeople — man becomes Superman, in the truest sense. Thus, Cordatum is a hatchery of sorts. But, note that we are not forging an ideal person. We prepare specialists, astronauts able to prevail in the conditions that will characterize the forthcoming space wars."

"But where's the Training Center?" I asked. "There's lush vegetation and native animals, but no structures."

"Inside the leaf," he said, tapping an organic portal to the hidden plane beneath the surface.

"Amazing," said Chris, "and well protected from Ferevoulf."

"Indeed," he said. "You should also know that Cordatum-3000 is capable of relocation on the planet surface to places rich in

cosmoenergetic potential. It sends out roots that suck up the earth's medicinal juices from the planet's depths and launches the finest invisible thorns to absorb particles of cosmic debris. It combines and converts all of these ingredients into a fine bioenergetic mixture."

"The Cordatum-3000 Cocktail," mused Chris.

"One powerful libation," I quipped.

"And most potent," said our instructor. "Every day, as you breathe this mixture, your bodies will strengthen and your minds will become as sharp as those thorns."

"We will evolve," said Chris, "within our own lifetime."

We were both giddy with excitement and fearful at the same time.

Hovering above the Dead Tree of Life

September 25. "*You* also need to get acquainted with that part of the island where the so-called Tree of Life is located," our instructor told us.

In less than a half-hour our levitoplan was hovering over a distant part of the island. Below, lay a town bisected by a road that went all the way from East to West, as far as our eyes could see. This main road and its arterials created a shape that was indeed similar to a tree.

"It reminds me of the Apocalypse," said Chris.

"How so?" Usually I could follow Chris's logic but this time I had no idea what prompted him make this connection.

"I read about a nuclear bomb dropped on a big city several centuries ago," he said without looking away from the terrain. "At the moment of detonation, it vaporized many of the inhabitants — all of whom perished — and burned their shadows into the surfaces of ruined buildings, bridges, and other structures that survived the blast. Those images must have looked much like this."

"It seems like the Tree of Life is a shadow of its former self," I said. "Wherever the people have derived their strength, the land is now barren."

"You'll see why," said our instructor as we got closer to the ground. Here, we could see people disappearing beneath the surface of the road. The surrounding land seemed to be breathing. From time to time it appeared as if waves passed over the surface. In an instant, the earth heaved up an enormous egg. Near by, gold spilled from an ancient jug, gleaming in the sunlight. Elsewhere, an enormous eye, like that of a poisonous snake, opened and began to glow in a hollow, casting a spell over travelers.

"I know this place," I said, barely realizing I was speaking out loud. "This is a Space War battlefield. Certainly, these people know that too and realize that with every step they're threatened with death from the toxins that remain here."

"These seekers," said the instructor, "take such a risk because they learned from the Teacher of Truth that one who passes through this course unharmed and reaches the Shining Peaks will find immortality. Today, I offer you both a choice: Travel the road below to potential immortality or avoid the associated risks and be content in your mortal existence."

As with so many other recent decisions, we thought of our options.

"So far," I said, "the road we have traveled has been no less worthwhile than this one."

"We conclude that there is no reason to risk cutting short the journey we are already on," said Chris.

The instructor smiled, "then you must leave these philosophical reflections until some future time. Your practical training at Cordatum-3000 will help you to make the first steps in this direction."

Battle
Rhinomachine

Voyage of the Newark

February 1, 2340. Journal entries or recordings of any kind were not allowed at the Cordatum-3000 Training Center. All I can say is that it was indeed a transforming experience. Since our return from the Cordatum, the past weeks have been busy, filled with preparations for departure on the new ship mentioned by our Supervisor. Waiting at the launching site on Bioassemblage Island inside the NEWARK, *I traced the graceful outlines of her interior to pass the time while systems were checked and rechecked before lift off. She is amazing and absolutely unlike any other space-craft. Flight is obtained when* NEWARK'S *enormous double wings flap. At first, the flight path seems chaotic like that of a butterfly flying over a field of flowers.* NEWARK *is perfectly capable of traversing huge distances in an extremely short time because this cosmic butterfly navigates through the space tunnels within black holes where biblical Time-World Olam reigns. Encounters with reefs and islands of Dark Matter are frequent in these tunnels, but* NEWARK'S *graceful maneuvers with the solar sails of its wings are well accomplished at avoiding them.*

We will fly rather often. After seeding the planets with biorobots we must return to inspect them. Spaceships from other planets have been known to infest our new worlds with disastrous viruses that hide built-in spirals of Evil. Ferevoulf's destruc-tive attempts grow more refined daily! Although our biorobots use the most advanced antivirus software, insidious nomad viruses are a constant threat. By worming themselves into our biorobots, these bugs can consume them just like a parasitic plant devours a mighty tree — by feeding on its juices.

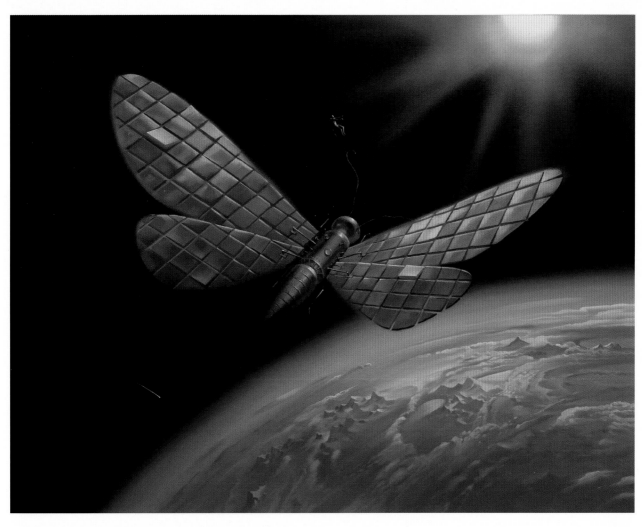

Plant Pierced and Recovered

February 4. We took an amazing plant — the True Heart — with us on our voyage. Cloned multiple copies of it are to be implanted into the biorobots as we release them. True Heart gives the biorobots the ability to exhibit human feelings, sympathy, and a yearning for Good. It was grown from hardy stock and is resistant to many perils. Without it, the biorobots would be susceptible to a release of Ferevoulf's Cold Heart Virus, a deadly abomination that unfolds spirals of Evil.

Uncrating the plant in our cargo hold in preparation for the cloning procedure, we gasped in horror: The Heart had been pierced by one of Dead Shot's arrows. But what an amazing wonder! Examining it more closely we found that the Heart had almost absorbed the arrow completely. This weapon had grown into the plant's fleshy core and turned into a life-giving artery! We knew that our cosmoplant breeders had created and nurtured the Heart near Precious Pearl — a source of bright energy. A wise choice, the Heart had developed an immunity to demonic energies. Its recuperative powers had the ability to absorb and neutralize Dark Matter like that which once formed Dead Shot's arrow.

Hearts for the Future
Generations

Crusaders versus Golems

February 10. We will fight a new weapon soon. Intelligence maintains that Ferevoulf is planning a series of local planetary wars using legions of demon-robots created by his bioconstructors. These are called Golems, and their aim is to trample all living beings on the planets we populate.

With their bioconstructors, the Golems live in labyrinthine caves located in a giant tentacle of Octopus City. They are extremely diverse, ranging in size and shape. They can be round, cylindrical, prismatic, etc. Some are dwarfs and others are giants. Rumors hold that there are formless, all-trampling Golem giants. Reliable intelligence indicates that all Golems have a tattoo of the last letter of the Greek alphabet — omega — on their foreheads. They are organized in a land horde commanded by the Great Bagatur and a sea horde that boasts Admiral Richard "Rifle" Cadoudal as its head.

Alarming signs have recently appeared in various regions of the sky. To protect our ship from Golems we took aboard a detachment of crusader robots commanded by General Cangrande the 2nd. Prior to departure, they marched along the deck below me in a sacred "iron fish" formation. Our experts say that only battling in this efficient and secure formation will secure victory over Ferevoulf's demonic Golems and help sweep them from our planets.

Shining Chitin
Armor

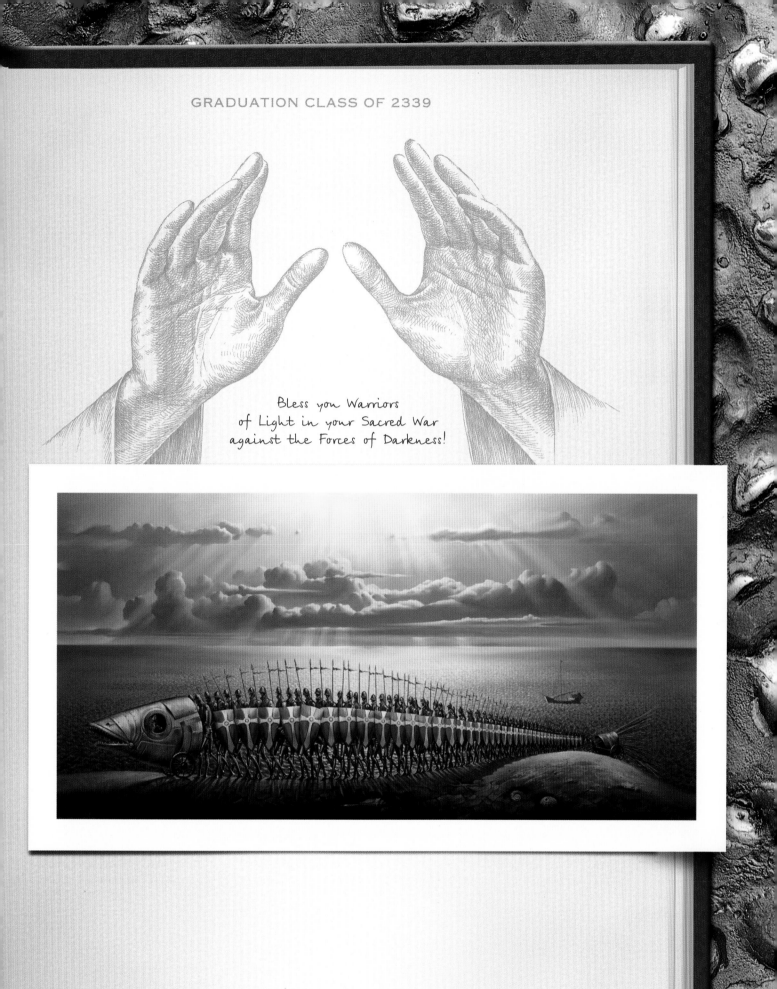

Bless you Warriors
of Light in your Sacred War
against the Forces of Darkness!

Haven in the Sky

February 29. For security reasons, this entry must end the diary of our exploits as we have found an unexpected haven in the sky that cannot be documented in any form. I've often wondered if my parents had any idea of the future that lay ahead of me when they gave me this journal. The inscription was unusually emotional for two scientists. To them, should they ever read this account, I say I have observed well and by doing so been able to provide valuable assistance. Partly because of their warning, I have braced myself for the unexpected and managed to stay safe. I can only hope they will join me here some day in the future.

Not all will have the luck to withstand the severe trials that were sent to us by the Sky Powers. For those that do, a safe Sky Haven sheltered in a cloudbank awaits them in a place rich with the golden fruits of new suns and the fair wind of chronons. So, prepare to let a mass migration of ARKS follow us to the Sky Haven, placing their sails in the sky as a symbol of mankind's voyage to the new shores in the waters of MetaCosmion!

To the New Haven

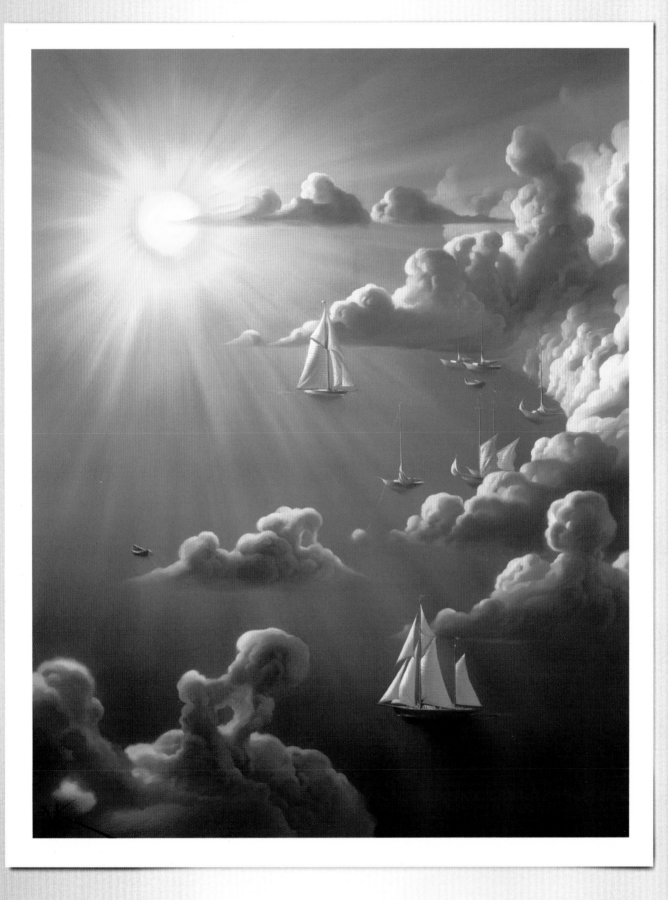

"Now you are seasoned soldiers of MetaCosmion," the Supervisor said. "The struggle between the Forces of Light and Forces of Darkness grows increasingly aggravated. To advance this competition for vital space in MetaCosmion, the Center has developed a sophisticated plan to use biorobots on the planets located in Near Space and then in Outer Space. They will support humankind in expanding the Space Frontier and fighting against the Dark Forces, which inundate the World with their torrid flood of Evil. We must stem the tide. Our place in history is not unlike that of the biblical hero Noah, who saved many living beings from the Great Deluge."

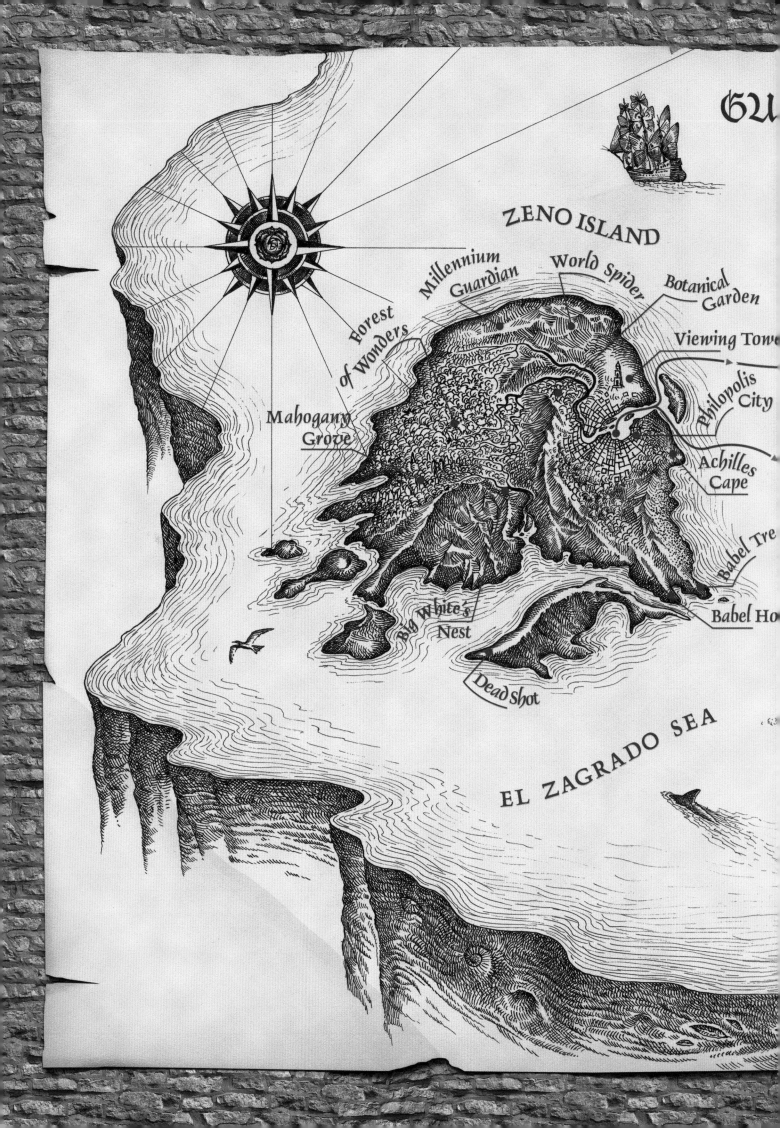

ZENO ISLAND

GU

Millennium
Guardian

World Spider

Botanical
Garden

Forest
of Wonders

Viewing Towe

Philopolis
City

Mahogany
Grove

Achilles
Cape

Babel Tre

Big White's
Nest

Babel Ho

Dead Shot

EL ZAGRADO SEA